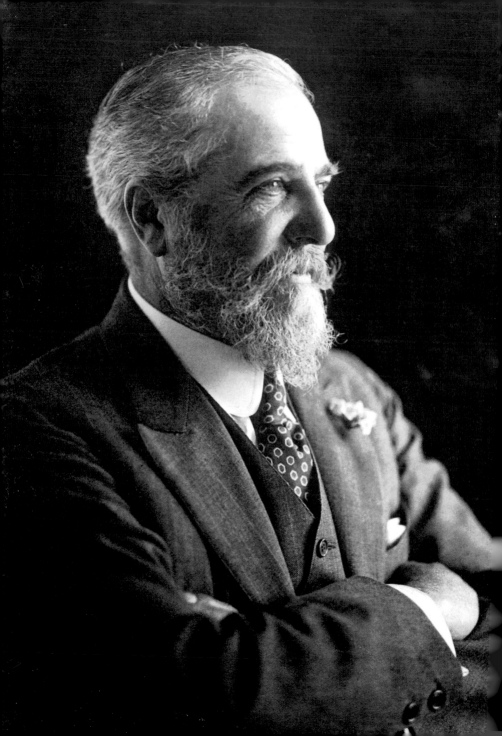

Louis Comfort

Tiffany

Jacob Baal-Teshuva

TASCHEN

KÖLN LONDON LOS ANGELES MADRID PARIS TOKYO

Tiffany: the man and his work

Tiffany: der Mann und sein Werk

Louis Comfort Tiffany (1848–1933) was the most important master of the decorative arts in America's "gilded age." He was a true visionary and one of the most original, creative, and influential designers of the period. Tiffany was the United States' leading proponent of Art Nouveau, the elegant, decorative and graceful style of ornamentation that flourished in Europe at the turn of the 20th century. He is also regarded as one of the first industrial designers to combine fine art and functional utility in his various creations, which are today known, appreciated and collected throughout the world. Tiffany was an industrious experimenter, obsessed with perfection and excellence, ideals he pursued to the fullest in his quest for a luxurious new aesthetic to suit American high style. Tiffany's widely varied career stretched over more than half a century, from 1870 to the middle of the 1920's. He possessed natural talent in numerous artistic fields. Early in his career Tiffany proved to be a gifted painter, an aspect of his work that often escapes public attention. He was also an architect, designed both landscapes and interiors, and created new styles for furniture, draperies, wallpaper, and rugs.

But as exquisite as these objects are, Tiffany is known all over the world as America's premier glass artist. Glass was the medium in which he excelled, for the intrinsic beauty of the material opened limitless creative possibilities and permitted him the optimal realization of his aesthetic ideas. Under his direct supervision, the expert artisans in his studios produced thousands of stained glass windows and lamps, tableware, mosaics and the most magnificent glass jewelry.

Louis Comfort Tiffany (1848–1933) war der bedeutendste Meister der dekorativen Künste im »goldenen Zeitalter« Amerikas. Er war ein wahrer Visionär und einer der originellsten, kreativsten und einflussreichsten Designer seiner Zeit. Tiffany war Führungsgestalt des Jugendstils in den Vereinigten Staaten schlechthin, des eleganten und anmutigen dekorativen Stils, der um die Wende zum 20. Jahrhundert in Europa seine Blütezeit erlebte. Er wird als einer der ersten Kunstindustrie-Designer betrachtet, der in seinen vielseitigen, in aller Welt bekannten, begehrten und gesammelten Schöpfungen Kunst und Funktionstüchtigkeit miteinander verband. Er war experimentierfreudig und besessen von dem Drang nach Perfektion und herausragender Leistung. So gelang ihm die Entwicklung einer neuen luxuriösen Ästhetik amerikanischen Stils, die höchsten Ansprüchen genügen sollte.

Tiffanys facettenreiche Karriere erstreckte sich über mehr als ein halbes Jahrhundert, von 1870 bis in die Mitte der 20er Jahre des 20. Jahrhunderts. In vielen künstlerischen Bereichen war er ein Naturtalent. Zu Beginn seiner Laufbahn erwies er sich als ein begabter Maler – ein Aspekt seines Schaffens, der häufig übersehen wird. Er war Architekt, Innenarchitekt und Landschaftsgestalter. Zudem entwarf er Möbel, Stoffe, Tapeten und Teppiche.

In aller Welt ist Tiffany aber vor allem als amerikanischer Glaskünstler bekannt. Die immanente Schönheit dieses Materials eröffnete ihm grenzenlose Gestaltungsmöglichkeiten, die es ihm gestatteten, seine ästhetischen Vorstellungen optimal umzusetzen. Unter seiner unmittelbaren Aufsicht brachten die besten Kunsthandwerker in seinen Studios Tausende von Buntglasfenstern sowie Lampen, Vasen, Tischdekorationen, Mosaiken und prachtvolle Schmuckstücke aus Glas hervor.

4

Tiffany: L'homme et l'œuvre

Louis Comfort Tiffany (1848–1933) fut le grand maître des arts décoratifs de l'«âge d'or» américain. Véritable visionnaire, il apparaît comme le designer le plus original, le plus inventif et le plus influent. Il fut aussi l'instigateur de l'Art Nouveau, style ornemental élégant, décoratif et gracieux qui s'épanouit en Europe au tournant du XXe siècle. Il est également considéré comme l'un des premiers designers industriels à allier sens artistique et utilité fonctionnelle dans ses diverses créations qui sont connues, appréciées et collectionnées aujourd'hui dans le monde entier. Tiffany fut un expérimentateur inlassable, habité par la perfection et le souci d'excellence dont il ne se départit jamais dans sa quête d'une nouvelle esthétique du luxe, adaptée aux exigences du style américain.

Sa carrière très diversifiée dura plus d'un demi-siècle, de 1870 jusque vers 1925. Il était doué de talents variés, dans diverses disciplines artistiques. D'abord, il se montra un peintre talentueux, un aspect de son œuvre souvent négligé aujourd'hui. Puis il se fit architecte et conçut des espaces paysagers et des décors intérieurs, ainsi que de nouveaux styles de meubles, de draperies, de papiers peints et de tapis.

Bien que ces objets soient d'un goût exquis, Tiffany est mondialement connu comme le plus grand verrier américain. Le verre fut le moyen d'expression où il excella car la beauté intrinsèque du matériau lui offrit d'immenses possibilités créatives et lui permit la réalisation optimale de ses conceptions esthétiques. Sous sa supervision directe, dans ses propres ateliers, des artisans chevronnés produisirent des milliers de vitraux, de lampes, de services de table, de mosaïques et de merveilleuses joailleries, le tout en verre de couleur.

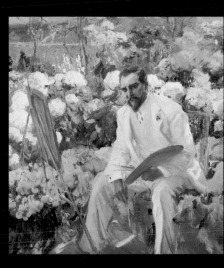

Louis Comfort Tiffany (detail), 1911
Painting by Joaquín Sorolla y Bastida.
Oil on canvas, 155 x 225 cm.

Louis Comfort Tiffany (Ausschnitt), 1911
Gemälde von Joaquín Sorolla y Bastida.
Öl auf Leinwand, 155 x 225 cm.

Louis Comfort Tiffany (détail), 1911
Tableau de Joaquín Sorolla y Bastida.
Huile sur toile, 155 x 225 cm.

Coll. The Hispanic Society of America, NY.

Charles Louis Tiffany, c. 1890.
Private collection.

*"Nature is always right"—that is a saying
we often hear from the past; and here is
another: "Nature is always beautiful."* (L.C.T.)

Louis Comfort Tiffany was born on February 18, 1848, the eldest son of Harriet and Charles Lewis Tiffany of New York City. C. L. Tiffany was the founder of Tiffany & Co., the most prestigious purveyor of jewelry, timepieces and silver objects in the world. Shortly after the company opened in 1837, the name of Tiffany became an international synonym for luxury, fine craftsmanship, good design and excellent taste. By 1870 its Fifth Avenue store was the place where presidents and royalty acquired the gifts they gave to visiting heads of state, with clients and recipients such as Queen Victoria of England, the czar of Russia and the khedive of Egypt. By 1900 Tiffany & Co. had over 1,000 employees working in its four branches located around the world, and Tiffany's personal fortune stood at around $11 million. Young Louis was raised in an environment of luxury and good design; however, to his father's disappointment, he displayed no interest in joining the family business. Instead, he announced that he would devote himself to the fine arts and pursue his own quest for beauty.

From 1862 to 1865 Tiffany attended the Eagleswood Military Academy in Perth Amboy, New Jersey. In 1865 he traveled to Europe for the first time, touring England, Ireland, France and Italy. In London he visited the Victoria and Albert Museum, whose extensive collection of Roman and Syrian glass made a deep impression on him.

Today, this same museum possesses a fine collection of Tiffany glass. Tiffany painted on site and documented many of the places he

Jugend und die Gründung der Firma

Jeunesse et création de la fabrique

»Die Natur hat immer recht«, besagt eine alte Redensart, und ich möchte dem hinzufügen: »Die Natur ist immer schön.« (L. C. T.)

«La nature a toujours raison» dit le vieux proverbe; et on pourrait ajouter: «La nature est toujours belle.» (L. C. T.)

Louis Comfort Tiffany wurde am 18. Februar 1848 als ältester Sohn von Harriet und Charles Lewis Tiffany in New York City geboren. Charles Lewis Tiffany hatte 1837 in New York das Unternehmen Tiffany & Co. gegründet, das schon nach wenigen Jahren zum weltweit renommiertesten Lieferanten für Juwelen, Uhren und Silberwaren und zu einem in aller Welt bekannten Synonym für Luxus, herausragende Qualität, gutes Design und exzellenten Geschmack wurde. Um 1870 hatte sich die Hauptniederlassung auf der Fifth Avenue als der Ort etabliert, wo Staatsoberhäupter wie Königin Victoria von England, der Zar von Russland und der Vizekönig von Ägypten die Kostbarkeiten erwarben, die bei Staatsbesuchen überreicht wurden. 1900 beschäftigte Tiffany & Co. in seinen insgesamt vier weltweiten Niederlassungen über 1000 Mitarbeiter, und Charles Lewis Tiffanys Privatvermögen wurde auf etwa 11 Mio. Dollar geschätzt. Der junge Louis wuchs in einer Welt des Luxus und des guten Geschmacks auf. Zur Enttäuschung seines Vaters zeigte er jedoch kein Interesse daran, in das Familienunternehmen einzutreten. Er wollte sich statt dessen den bildenden Künsten und seiner eigenen Suche nach Schönheit widmen. Von 1862 bis 1865 besuchte Tiffany die Militärakademie Eagleswood in Perth Amboy, New Jersey. 1865 reiste er zum ersten Mal nach Europa. Die Reise führte ihn durch England, Irland, Frankreich und Italien. In London besuchte er das Victoria and Albert Museum mit seiner großartigen Sammlung römischer und syrischer Gläser, von der er zutiefst beeindruckt war. Heute

Louis Comfort Tiffany est né à New York le 18 février 1848, premier fils de Harriet et Charles Lewis Tiffany. Charles Lewis Tiffany avait fondé Tiffany & Co., un des fournisseurs en bijoux, mécanismes d'horlogerie et pièces d'argenterie les plus prestigieux du monde. Peu après son ouverture en 1837, la compagnie était devenue, dans le monde entier, synonyme de luxe, d'exécution minutieuse, de finesse de conception et d'excellence de goût. Vers 1870, le magasin de la 5ème Avenue devenait le lieu où rois, reines et présidents faisaient acquisition des présents destinés aux chefs d'Etat en visite. On pouvait noter parmi d'autres la reine Victoria, le Tsar de toutes les Russies ou le Khédive d'Egypte. Aux alentours de 1900, Tiffany & Co. employait plus de 1000 personnes, dans ses quatre succursales de par le monde et la fortune personnelle de Charles Lewis Tiffany s'élevait à environ 11 millions de dollars. Le jeune Louis grandissait donc dans le luxe et la beauté. Toutefois, et pour le plus grand déplaisir de son père, il ne montrait aucun intérêt pour l'entreprise familiale et annonça son intention de se consacrer aux arts et à sa propre quête de la beauté.

Entre 1862 et 1865, il fréquente l'Ecole militaire de Eagleswood, à Perth Amboy, dans le New Jersey. En 1865, il part pour sa première visite en Europe. Il parcourt l'Angleterre, l'Irlande et l'Italie. A Londres, il se rend au Victoria and Albert Museum, où il est fort impressionné par l'importante collection de verres romains et syriens. Aujourd'hui, dans ce même musée, est venue s'ajouter la plus im-

visited in sketches and photographs, as well. Upon his return to New York he enrolled for a year in the National Academy of Design where, in 1867, he first exhibited paintings inspired by his European travels.

Tiffany not only possessed a unique artistic vision, he was also a savvy businessman and had natural marketing ability. In addition, he was in a position to draw upon his father's reputation for quality goods. Tiffany gathered three of his friends—textile designer Candace Wheeler and the painters William H. de Forest and Samuel Colman—and formed an interior design firm called L. C. Tiffany and Associated Artists. The company was in business for just four years, from 1879 to 1883. The group provided original designs for wallpaper, textiles and furniture produced from local materials by American artisans. Tiffany and his associates decorated the homes of many of the wealthiest and most prominent families in America, including those of Andrew Carnegie, Henry Osborne Havemeyer, John Taylor Johnston (then president of the Metropolitan Museum of Art), Cornelius Vanderbilt II, and the writer Mark Twain. Havemeyer accumulated a large collection of Tiffany glass that he later donated to the Metropolitan Museum of Art in New York. In 1883 L.C. Tiffany & Associated Artists disbanded, in large part because Tiffany had become increasingly interested in working almost exclusively in glass. The breakup was friendly, and the other two members went on to pursue independent projects. Tiffany was free to accept design projects on his own and did so, but increasingly he focused his energies on developing new ways to further his goal of infusing the world with the color he so loved.

besitzt dieses Museum auch eine prächtige Sammlung von Tiffany-Gläsern. Tiffany hielt viele Stationen seiner Europareise auf Skizzen fest. Nach seiner Rückkehr nach New York schrieb er sich für ein Jahr an der National Academy of Design ein, wo er 1867 in seiner ersten Ausstellung Gemälde zeigte, die auf seine Europareise zurückgingen.

Tiffany war nicht nur ein begabter Künstler, sondern gleichzeitig auch ein hervorragender Geschäftsmann und ein großes Marketingtalent. Darüber hinaus konnte er auf dem guten Namen seines Vaters aufbauen. Zusammen mit drei Freunden – der Textilkünstlerin Candace Wheeler und den Malern Samuel Colman und Lockwood de Forest – gründete er 1879 eine auf Inneneinrichtungen spezialisierte Firma, die vier Jahre lang, bis 1883, bestehen sollte: Louis C. Tiffany & Associated Artists. Tiffany und seine Freunde lieferten nach neuen Entwürfen gestaltete Tapeten, Textilien und Möbel, die aus heimischen Materialien von amerikanischen Handwerkern gefertigt wurden. Die bekanntesten und reichsten amerikanischen Familien ließen ihre Häuser von Tiffany und seinen Geschäftspartnern ausstatten: die Großindustriellen Andrew Carnegie, Cornelius Vanderbilt II und Henry Osborne Havemeyer, John Taylor Johnston, der Präsident des Metropolitan Museum of Art in New York, und der Schriftsteller Mark Twain, um nur einige zu nennen. Henry Osborne Havemeyer sammelte zahlreiche Tiffany-Gläser, die er später dem Metropolitan Museum of Art schenkte. 1883 wurde Louis C. Tiffany & Associated Artists aufgelöst, hauptsächlich weil Tiffany selbst sich auf die Beschäftigung mit Glas zu konzentrieren begonnen hatte. Die Trennung erfolgte in freundschaftlichem Geist, und seine Partner gingen eigene Wege. Tiffany führte zwar noch einige Ausstattungsaufträge aus, doch mehr und mehr wandte er sich der Suche nach neuen Möglichkeiten zu, der Welt die denkbar schönsten Farben zu schenken.

pressionnante collection de verreries Tiffany. Le jeune homme réalise alors d'innombrables croquis dans les villes qu'il visite. Rentré à New York, il suit pendant un an les cours de la National Academy of Design où, en 1867, il expose pour la première fois ses tableaux d'inspiration européenne.

Doué d'une vision artistique exceptionnelle, Tiffany possède aussi un formidable sens des affaires et du commerce. De plus, en matière de qualité, il peut s'appuyer sur la réputation de son père. Avec trois de ses amis, Candace Wheeler, dessinateur sur textile, et les peintres Samuel Colman et Lockwood de Forest, Tiffany crée une entreprise de décoration intérieure, la L. C. Tiffany & Associated Artists. Ils fonctionnent pendant quatre ans, de 1879 à 1883.

Le groupe propose de nouveaux motifs de papiers peints, textiles et meubles, produits à partir de matériaux locaux et confiés à des artisans américains. Tiffany et ses associés décorent les maisons des familles les plus riches et les plus célèbres comme celles de Andrew Carnegie, Cornelius Vanderbilt II, Henry Osborne Havemeyer, John Taylor Johnson (président du Metropolitan Museum of Art), ou de l'écrivain Mark Twain. Havemeyer rassemble une importante collection de verres de Tiffany, dont il fera don au Metropolitan Museum of Art de New York.

En 1883, L. C. Tiffany & Associated Artists se séparent, surtout parce que Tiffany s'intéresse désormais presque exclusivement au verre. La rupture est amicale et les deux autres continuent de poursuivre, indépendamment, leurs projets. Tiffany peut maintenant se consacrer librement aux siens et propager, dans le monde entier, ces couleurs qu'il aime tant.

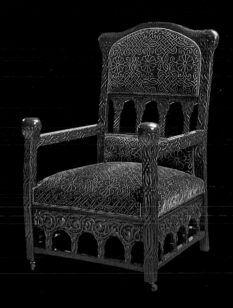

Ornate carved-wood armchair designed by Louis Comfort Tiffany and Samuel Colman, c. 1891/1892.

Armsessel mit geschnitzten Verzierungen, entworfen von Louis Comfort Tiffany und Samuel Colman, um 1891/1892.

Fauteuil amplement décoré, ébauché par Louis Comfort Tiffany et Samuel Colman, vers 1891/1892.

Private collection.

Light upon color:
Tiffany's glass windows

__"Make a material in which colors and combinations of colors, shades, hues, tints and tones [are] there without surface treatment as far as possible."__ (L. C. T.)

However, as much as Tiffany admired the coloration of medieval glass, he was convinced that the quality of contemporary glass could be improved upon. In his own words, the "rich tones are due in part to the use of pot metal full of impurities, and in part to the uneven thickness of the glass, but still more because the glass maker of that day abstained from the use of paint." Tiffany did not like the contemporary technique of painting onto the glass, which he felt obscured and disturbed the natural transparency of glass. Instead, he wanted the glass itself to transmit texture and rich colors, and he spent much of his life experimenting to find a means to duplicate—and eventually greatly exceed—the effect of the medieval stained glass he so admired. Tiffany's respect for the innate properties of glass led him to his greatest innovation—the development of a type of glass he called Favrile.

Favrile glass was a major breakthrough for Tiffany, to his mind surpassing even the best of the 13th-century glasswork. He used Favrile glass with its haunting iridescent colors in all his windows, lamps, vases, and mosaics. According to experts, Favrile glass also served as an emancipation for the art of creating pieced glass windows. It opened possibilities both pictorially and decoratively, pictorially because of the limitless atmospheric effects one can achieve with it, and decoratively because of the intrinsic beauty of the material. In fact, Favrile glass was admired for its delicacy, and was described in contemporary literature as resem-

Trademark for Tiffany Glass and Decorating Company issued in 1894, used 1892–1902.

Geschütztes Warenzeichen der Tiffany Glass and Decorating Company. 1894 offiziell angemeldet, war es von 1892 bis 1902 in Gebrauch.

Marque de fabrique de la Tiffany Glass and Decorating Company issue en 1894. Elle fut utilisée de 1892 à 1902.

Private collection.

Licht auf Farbe:
Tiffanys Glasfenster

»Ein Material, welches Farben und Farb-
kombinationen, Schattierungen, Farbtöne und
Nuancen so weit wie möglich ohne Ober-
flächenbehandlung enthält.« (L. C. T.)

Tiffany bewunderte die farbenfrohen Buntglas-
fenster aus dem Mittelalter: »Ihre reichen Far-
ben haben ihre Ursache teils in der Verwen-
dung einer mit Verunreinigungen angefüllten
Schmelzmasse, teils in der ungleichmäßigen
Dicke des Glases, vor allem sind sie jedoch da-
mit zu erklären, dass die Glasmacher jener Zeit
keine Farben verwendeten.« Einen großen Teil
seines Lebens widmete Tiffany der Suche nach
Möglichkeiten, die Qualität dieses farbigen Gla-
ses zu erreichen oder gar zu übertrumpfen. Im
19. Jahrhundert war es üblich geworden, die
Glasoberfläche zu bemalen, was die natürliche
Transparenz des Materials beeinträchtigte. Tif-
fany wollte stattdessen ein Glas entwickeln,
das selbst, ohne äußere Behandlung, eine an-
sprechende Textur und satte Farben zeigte.
Und seine Experimente waren schließlich von
Erfolg gekrönt. Mit der Entwicklung einer Glas-
sorte, die er »Favrile« nannte, gelang ihm seine
bedeutendste Erfindung.
Das Favrile-Glas bedeutete für Tiffany einen
wichtigen Durchbruch. Seiner Überzeugung
nach übertraf es mit seinen irisierenden Far-
ben qualitativ selbst die besten Gläser, die den
Glasmalern der Gotik zur Verfügung gestanden
hatten. Er verwendete es für alle seine Bunt-
glasfenster, Lampen, Vasen und Mosaiken. Das
Favrile-Glas war Experten zufolge sowohl in ge-
stalterischer – der grenzenlosen Möglichkeiten
wegen, atmosphärische Wirkungen zu errei-
chen – als auch, der immanenten Schönheit des
Materials wegen, in dekorativer Hinsicht von
emanzipatorischer Bedeutung für die Kunst der

Lumière sur couleur:
les vitraux Tiffany

«Créer un matériau dans lequel les couleurs,
avec leurs combinaisons, leurs nuances, leurs
teintes et leurs tonalités sont présentes sans,
si possible, le moindre traitement de surface.»
(L. C. T.)

Pour grand admirateur qu'il soit des colorati-
ons du verre médiéval, Tiffany émet quelques
réserves quant à la qualité de la production
d'alors. Il déclare: «La richesse des tons est due
en partie à l'utilisation de métal de creuset,
plein d'impuretés, en partie à l'épaisseur irré-
gulière du verre, mais surtout au fait que le
verrier de l'époque s'est bien gardé d'utiliser
de la peinture.» Tiffany va passer une grande
partie de sa vie à trouver le moyen de repro-
duire, voire d'améliorer l'effet tant admiré. Il
n'aime guère la technique d'alors qui consiste
à peindre sur le verre. Pour lui, cela obscurcit
et perturbe la transparence naturelle du verre.
Il préfère que le verre révèle sa texture et la
richesse de ses nuances. C'est ce respect pour
le verre qui va le mener à sa plus grande dé-
couverte: ce verre qu'il nomme Favrile.
Pour Tiffany, il s'agit d'une percée de première
importance, surpassant, à ses yeux les meil-
leures verreries du XIIIe siècle. Il va utiliser ce
verre Favrile avec ses fascinantes couleurs
irisées, pour tous ses vitraux, ses lampes, ses
vases et ses mosaïques. Selon certains experts,
le verre Favrile est aussi un facteur d'épanoui-
issement pour l'art du vitrail. Il ouvre des pos-
sibilités à la fois sur les plans artistique et dé-
coratif: artistique aux possibilités illimitées des
effets d'atmosphère, et décoratif en raison de
la beauté intrinsèque du matériau. D'ailleurs,
le verre Favrile est surtout admiré pour sa dé-
licatesse: dans la littérature de l'époque, on le
compare à «des ailes de papillons et de paons,

bling "wings of butterflies and peacocks with their magic colors." In a very short time, the Tiffany Glass Company (later called the Tiffany Glass and Decorating Company) became America's leading supplier of stained glass windows. Among his clients were New York's Colonial Club, James B. Castle, P. B. Griffin and others. Tiffany produced memorial windows depicting several U. S. presidents including Benjamin Harrison, Abraham Lincoln, Theodore Roosevelt, and Chester A. Arthur. Some of the country's most important academic institutions boast Tiffany windows, among them Brown, Columbia, Harvard, Hotchkiss, Princeton and Yale Universities; Dartmouth, Vassar and Wellesley Colleges; and Hotchkiss Academy. Over the course of his career Tiffany received many commissions for stained glass windows from art museums such as the Smithsonian Institution in Washington D. C. and the Chicago Art Institute. He even produced a dramatic window triptych for the Red Cross's headquarters in Washington D. C.

It was through his window designs that Tiffany had first collaborated with S. Bing, and their relationship was to revolutionize the history of decorative art worldwide. Bing's gallery was frequented at the time by the likes of Van Gogh, who browsed Bing's Japanese prints, which later influenced his paintings. Tiffany had visited Bing's gallery when he was in Paris for the 1889 Exposition Universelle and was surprised to see that a La Farge window had received much attention and praise. This only served to increase Tiffany's motivation to produce more exciting and better-quality windows. He asked Bing to consider selling his secular windows and other objects in glass, and Bing made a point of visiting Tiffany during a trip to the United States in 1894. Impressed by Tiffany's work, in 1895 Bing commissioned 11 young Parisian artists to create artwork to be

Buntglasfenstermosaiken. Das Favrile-Glas wurde seiner Zartheit und seiner magischen Farben wegen bewundert und in der zeitgenössischen Literatur mit »Schmetterlings- und Pfauenflügeln« verglichen. In kürzester Zeit wurde die Tiffany Glass Company (später Tiffany Glass & Decorating Company) zum wichtigsten Lieferanten für Buntglasfenster in Amerika. Zu ihren Auftraggebern zählten unter anderen der New Yorker Colonial Club, James B. Castle und P. B. Griffin. Tiffany schuf Memorial-Fenster mit Darstellungen verschiedener Präsidenten wie Benjamin Harrison, Abraham Lincoln, Theodore Roosevelt und Chester A. Arthur. Er fertigte Fenster für einige der wichtigsten akademischen Institutionen der USA, zum Beispiel für die Universitäten Yale, Princeton, Harvard, Columbia, Brown und Hotchkiss, für die Colleges Vassar, Dartmouth und Wellesley sowie für Kunstmuseen wie das Smithsonian in Washington, D. C., und das Art Institute in Chicago. Für die Zentrale des amerikanischen Roten Kreuzes stellte er ein dramatisches dreiteiliges Fenster her.

Über seine Glasfensterentwürfe kam Tiffany auch mit Siegfried Bing in Kontakt, und aus dieser ersten Begegnung ging eine Verbindung hervor, die die Geschichte der dekorativen Kunst revolutionieren sollte. Bings Galerie wurde damals auch von Avantgardekünstlern wie van Gogh besucht, der sich dort von japanischen Graphiken inspirieren ließ. 1889 reiste Tiffany zur Weltausstellung nach Paris, wo zu seiner Überraschung ein Buntglasfenster seines Konkurrenten John La Farge große Beachtung und Zustimmung fand. Für Tiffany war das ein Ansporn, die Qualität seiner eigenen Fenster noch zu steigern. Er suchte Bing in seiner Galerie auf und machte ihm den Vorschlag, seine säkularen Glasfenster und andere Glasobjekte in das Programm der Galerie aufzunehmen. Als Bing 1894 in die Vereinigten Staaten reiste, be-

aux couleurs magiques». Très vite, la Tiffany
Glass Co. (qui allait prendre le nom de Tiffany
Glass and Decorating Co.) devient le premier
fournisseur de vitraux américain. Parmi ses
clients, on compte le Colonial Club de New
York, James B. Castle, P. B. Griffin et bien
d'autres. Tiffany fournit des vitraux commé-
moratifs, représentant divers présidents
américains dont Benjamin Harrison, Abraham
Lincoln, Theodore Roosevelt et Chester A. Ar-
thur. Certaines institutions universitaires,
parmi les plus réputées, s'enorgueillissent de
vitraux Tiffany, en particulier Yale, Princeton,
Dartmouth College, Harvard, Columbia, Brown,
Vassar College, Wellesley College et Hotchkiss
University. Au cours de sa longue carrière, Tif-
fany reçoit de nombreuses commandes de vit-
raux pour des musées comme la Smithsonian
Institution à Washington D. C. ou le Chicago Art
Institute. Il fabrique même un impressionnant
triptyque pour le siège social de la Croix Rouge
à Washington D. C.
Ayant commencé sa collaboration avec S. Bing
grâce à ses vitraux, Tiffany va ensuite, avec
ce dernier, révolutionner l'histoire des arts dé-
coratifs, dans le monde entier. A l'époque, la
galerie Bing est surtout fréquentée par des
gens comme Van Gogh, qui venait là admirer
les estampes japonaises et s'en inspirer pour
ses peintures. Tiffany visite pour la première
fois la galerie Bing lors de son voyage pour
l'Exposition Universelle de 1889 et découvre, à
sa grande surprise, l'accueil très favorable ré-
servé alors à un vitrail de La Farge. Cela ne
fait que renforcer sa motivation à produire des
vitraux encore plus beaux et plus remarqua-
bles. Il demande alors à Bing s'il accepterait de
se charger de la vente de ses vitraux et autres
objets en verre. Quand il vient aux Etats-Unis,
en 1894, Bing va donc rendre visite à Tiffany.
Impressionné par ce qu'il découvre, Bing com-
mande en 1895, à onze jeunes artistes parisi-

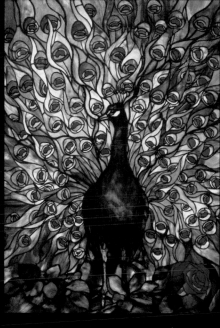

Peacock leaded glass window, c. 1910
84 x 61 cm.
Christie's Images.

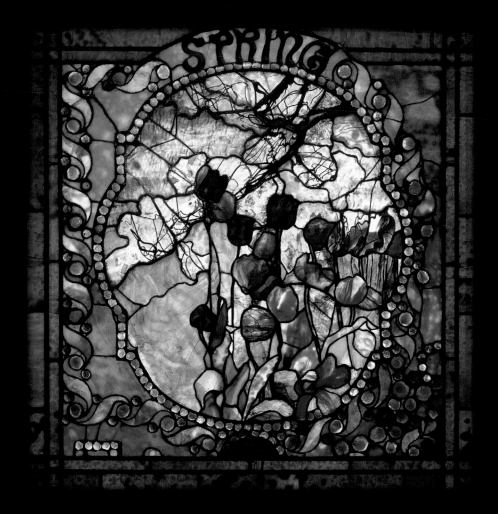

**Four Seasons windows, all c. 1899–1900
(created for the 1900 Exposition Universelle in Paris)**

*Collection of the Charles Hosmer Morse Museum
of American Art, Winterpark FL.*
© The Charles Hosmer Morse Foundation Inc.
Photos: Alan Maxwell

Spring
103.6 x 99.1 cm.

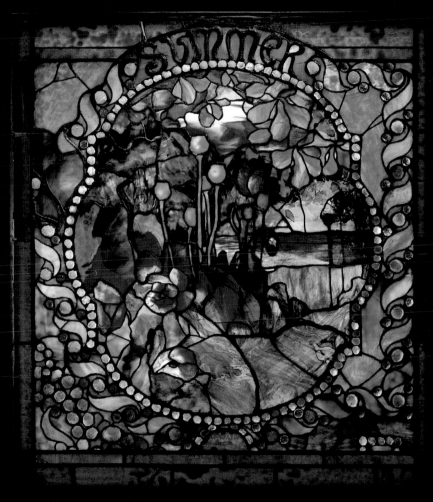

Summer
99.1 x 95.9 cm.

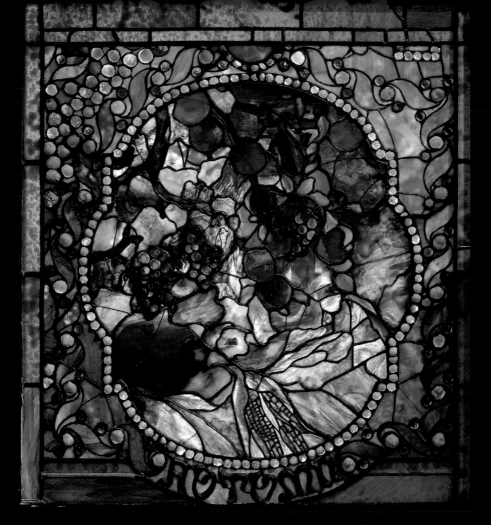

**Four Seasons windows, all c. 1899–1900
(created for the 1900 Exposition Universelle in Paris)**

*Collection of the Charles Hosmer Morse Museum
of American Art, Winterpark FL.
© The Charles Hosmer Morse Foundation Inc.
Photos: Alan Maxwell*

Autumn

99.1 x 93 cm.

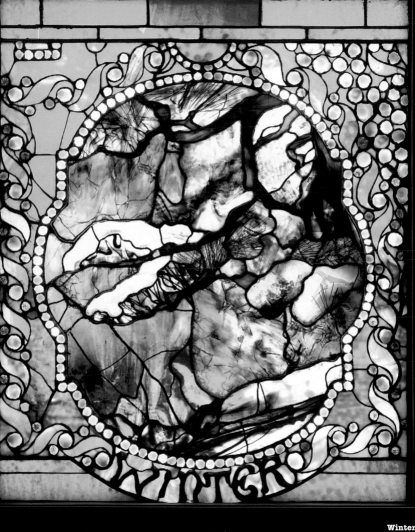

Winter
99.1 x 81.3 cm

translated into Tiffany's glass windows. Among the artists were Pierre Bonnard, Eduard Vuillard and Maurice Denis—all members of the avant-garde art movement known as the Nabis—and Henri de Toulouse-Lautrec. Bing's commission put Tiffany at the center of the Parisian and international art scenes, and Tiffany in turn wanted to prove to the world that no painting could capture the brilliance of light and color as beautifully as his windows did. Shortly after Tiffany's Four Seasons window series had been exhibited in Paris in the Exposition Universelle of 1900, Bing displayed them at the Grafton Galleries in London. From all accounts they won praise for the vibrant colors of their compositions depicting the seasons of the year in colorful landscapes, florals and spectacular renderings of nature. Bing and Tiffany remained friends and business associates until Bing's death in 1905.

Color upon light:
Tiffany's lamps and shades

The sovereign importance of color is only beginning to be realized. (L. C. T.)

To many people throughout the world, the name Tiffany brings to mind his stunning lampshades. Artistically, however, his stained glass windows preceded them; production of his more popular lampshades was a by-product using the many thousands of pieces of glass that remained after cutting individual elements for the windows. Tiffany began selling blown-glass shades in the mid-1890's and leaded glass shades around 1898. Peak production of Tiffany lamps occurred between 1900 and 1914, although they continued to be made well into the 1930's. The lamps allowed more people to appreciate the striking beauty of Favrile glass

suchte er Tiffany in New York und war von seinen Arbeiten tief beeindruckt. 1895 gab er bei elf jungen französischen Künstlern – darunter Pierre Bonnard, Edouard Vuillard und Maurice Denis, allesamt Mitglieder der als »Nabis« bekannten Avantgardebewegung, sowie Henri de Toulouse-Lautrec – Glasfenstervorlagen für Tiffany in Auftrag. Bings Auftrag rückte Tiffany in den Mittelpunkt der Pariser und der internationalen Kunstszene und gab ihm die Möglichkeit, der Welt zu beweisen, dass die Brillanz des Lichts und der Farben seiner Glasfenster von keinem Gemälde übertroffen werden konnte. Tiffanys Buntglasfenster The Four Seasons (»Die vier Jahreszeiten«) wurden auf der Pariser Weltausstellung von 1900 präsentiert, und Bing ließ sie kurz darauf auch in den Grafton Galleries in London ausstellen. Die glühenden Farben und die Komposition mit ihren farbenfrohen Landschaften, Blumen und spektakulären Naturszenen brachten den Fenstern große Bewunderung ein. Bis zu Bings Tod im Jahre 1905 blieben er und Tiffany Freunde und Geschäftspartner.

Farbe auf Licht: Tiffanys
Lampen und Lampenschirme

Wir sind eben erst dabei, die herausragende Bedeutung der Farbe zu erfassen. (L. C. T.)

Viele Menschen in aller Welt denken bei dem Namen Tiffany zunächst an seine atemberaubend schönen Lampen. Ursprünglich waren die Lampenschirme allerdings nur »Nebenprodukte« aus den Tausenden kleineren Glasfragmenten, die bei der Produktion der bleiverglasten Fenster übrig blieben. Die ersten Lampenschirme aus geblasenem Glas entstanden um 1895, die ersten bleiverglasten um 1898. Die Produktion hatte ihre Blütezeit zwi-

ens des projets qui ont été transposés en verre sur vitraux Tiffany. Parmi eux, figurent Pierre Bonnard, Edouard Vuillard et Maurice Denis – tous trois membres du mouvement avant-gardiste des Nabis. Cette commande de Bing place Tiffany au centre de la scène artistique parisienne et internationale, et il est bien déterminé à prouver au monde qu'aucune peinture ne saurait saisir l'éclat de la lumière et de la couleur mieux que ses vitraux. Quand «Les Quatre saisons» sont présentés à l'Exposition Universelle de 1900, Bing décide de les exposer aux Grafton Galleries de Londres, immédiatement après. Selon tous les témoignages, les œuvres sont acclamés pour ses couleurs éclatantes et sa composition sur le thème des saisons, avec des paysages colorés, des motifs floraux, et d'impressionnants rendus de la nature. Bing et Tiffany devaient rester amis et associés jusqu'à la mort de Bing, en 1905.

Couleur sur lumière: lampes et abat-jour Tiffany

L'importance absolue de la couleur commence seulement à être reconnue. (L. C. T.)

Pour beaucoup de gens, et dans le monde entier, le nom de Tiffany évoque ces fantastiques lampes de verre. On ne sait pas toujours que, du point de vue artistique, ses vitraux furent créés en premier. La fabrication de ses abat-jour les plus célèbres a d'abord constitué une production secondaire, pour utiliser les milliers de morceaux de verre restant après la coupe des éléments destinés aux vitraux. Tiffany commença à vendre des abat-jour en verre soufflé vers 1895, et ceux en mosaïque de verre aux alentours de 1898. La production culmine entre 1900 et 1914, même si elle se poursuit jusqu'à la fin des années 1930. Ces

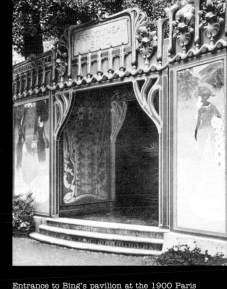

Entrance to Bing's pavilion at the 1900 Paris Exposition.

Eingang zu Bings Pavillon auf der Weltausstellung in Paris, 1900.

Entrée du pavillon de Bing à l'Exposition Universelle de Paris, 1900.

Private collection.

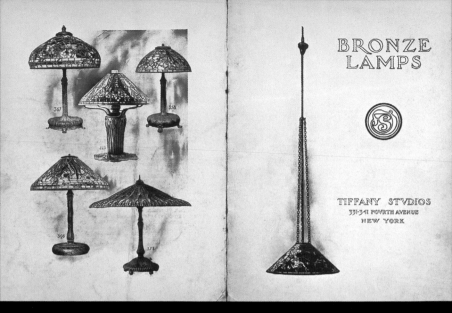

and to enjoy it in their very homes. The subjects of his lamps were primarily floral, with a seemingly limitless range of colors; however, Tiffany also designed lamps with geometric patterns. The lamp base was usually made of metal (in some cases with mosaic), sometimes designed for a particular shade pattern but most often able to be combined with any shade. No one knows precisely how many lamps were produced in total, but a 1906 catalogue listed over 300 available models.

In 1900 an average Tiffany lamp was priced at $100, with smaller lamps starting at $40. They were luxury items that no well-to-do American who wished to live in style was willing to do without. Wealthy Europeans were able to acquire them in Paris from S. Bing's gallery, Tiffany's exclusive European representative. Never-

schen 1900 und 1914 und wurde bis weit in die 30er Jahre hinein fortgesetzt. Die Lampen boten einer breiteren Bevölkerungsschicht die Möglichkeit, sich in der privaten Umgebung ihrer Häuser und Wohnungen an der Schönheit der Favrile-Gläser zu erfreuen. Die meisten Lampen zeigen Blumenmotive in einer scheinbar grenzenlosen Farbpalette, einige weisen jedoch auch geometrische Formen auf. Die Füße sind meist aus Metall gefertigt und können mit jedem beliebigen Lampenschirmmodell kombiniert werden; nur manchmal ist ein Fuß auf einen bestimmten Lampenschirm zugeschnitten. Niemand kann mit Gewissheit sagen, wie viele Lampen insgesamt produziert wurden. In einem Katalog von 1906 zum Beispiel wurden jedoch mehr als 300 verschiedene Modelle angeboten.

lampes vont permettre a plus de gens d'apprécier la beauté saisissante du verre Favrile, et d'en acheter pour leur foyer. A l'origine, l'inspiration de ces lampes était essentiellement florale, dans une gamme de couleurs apparemment sans limite. Toutefois, Tiffany crée aussi des lampes à motifs géométriques. Le pied est généralement en métal, parfois conçu pour un abat-jour en particulier, mais le plus souvent adaptable à tout modèle. Nul ne sait précisément le nombre total de lampes qui est produit alors. Mais un catalogue daté de 1906 présente une liste comprenant pas moins de 300 modèles disponibles.

En 1900, une lampe standard est cotée en moyenne à environ 100 dollars et à 40 pour les plus petites. Il s'agit d'articles de luxe dont aucun Américain aisé, désirant vivre dans un certain raffinement, ne saurait se passer. Les Européens riches peuvent les acquérir à Paris, à la Galerie Bing, représentant exclusif de Tiffany. Pourtant, même si la plupart de ses clients privés sont de riches Américains et si ses objets sont chers pour l'époque, Tiffany sait que dépenser de grosses sommes d'argent ne suffit pas pour créer un bel intérieur. En 1910, il explique: «Ce n'est pas la dépense excessive qui engendre la beauté, et nombre de nos citoyens les plus riches, comme d'autres plus pauvres, n'ont pas encore compris la valeur du bon goût. En fait, l'argent est souvent un obstacle au bon goût, car il mène à l'étalage et à trop de complications.»

Parmi les lampes Tiffany, se trouvent plusieurs variétés, simples ou complexes, petites ou grandes, sans artifices ou somptueusement élaborées. Certaines sont en forme de cône ou de globe. Il y a des lampes de table, des lampadaires et des lampes suspendues (Tiffany nomme certains modèles «bouquets suspendus»). Toutefois, ce sont surtout les innombrables lampes florales, avec leur fameux pied en bronze

theless, although most of his private clients were America's wealthiest families and his works were high-priced for their time, he felt that spending large amounts of money was not necessarily a prerequisite for creating a beautiful home. He said in 1910: "Extravagance does not produce beauty; and many of our richest people, like some of our poor people, have not yet come to see the value of good taste. In fact, money is frequently an absolute bar to good taste, for it leads to show and over-elaboration."

Tiffany's lamps included myriad models, from simple to complex, small to large, from quite plain to sumptuous and elaborate. There were lamps shaped like cones and globes, table lamps, floor lamps and hanging lamps (some models of which Tiffany dubbed "hanging bouquets"). However, it is the floral lamps, with their characteristic ornate bronze bases, some of which incorporate glass mosaics, that are most highly sought by collectors today. The wide variety of flowers Tiffany used as subjects for his shades includes geraniums, magnolias, poppies, clematis, poinsettia, water lilies, daffodils, tulips, peonies, nasturtiums, narcissi, begonias, hydrangeas, laburnum, roses, apple and cherry blossoms, and wisteria. He also used bamboo leaves and grapevines as well as exotic fruit such as pineapple. Certain shade styles—such as the Elizabethan, Empire Jewel, Venetian, and Russian models—recall periods in history. His Dragonfly shade was extremely popular, and was produced in a wide variety of shapes, sizes and colors. Some of the complex designs incorporate over a thousand pieces of glass in a single lampshade.

The Lotus lamp is one of the most magnificent leaded shade/base combinations ever produced by Tiffany Studios. The lotus motif has its roots in Egyptian and Indian cultures, and for artists of the Art Nouveau movement in France the

Der Preis für eine Lampe durchschnittlicher Größe betrug zu Beginn des 20. Jahrhunderts 100 Dollar, kleinere Lampen wurden schon ab 40 Dollar angeboten. Lampen, Vasen und andere Objekte aus Tiffanys Werkstätten waren Luxusartikel, auf die kein wohlhabender, prestigebewusster Amerikaner verzichten wollte. In Europa wurden sie von Siegfried Bing in seiner Pariser Galerie vertrieben. Obwohl die meisten seiner Kunden aus den wohlhabendsten amerikanischen Familien stammten und seine Arbeiten für die damalige Zeit sehr teuer waren, war Tiffany davon überzeugt, dass ein Heim auch mit wenig Geld schön eingerichtet werden könne. 1910 sagte er dazu: »Verschwendung bringt keine Schönheit hervor, und wie einige arme Leute haben auch viele sehr Reiche den Wert des guten Geschmacks noch nicht erkannt. Oft schiebt das Geld dem guten Geschmack sogar einen Riegel vor, weil es zu Protzertum und Prunksucht verführt.«

Tiffanys Lampen können in verschiedene Kategorien unterteilt werden: Es gibt einfache und komplexe, kleine und große, schlichte und aufwendig gestaltete. Es gibt Lampen in der Form von Kegeln oder Kugeln, Tisch-, Steh- und Hängelampen, darunter die Modelle, die Tiffany als »hängende Bouquets« bezeichnete. Unter heutigen Sammlern besonders gefragt sind jedoch die vielen »Blumenlampen« mit ihren charakteristischen, reich – manchmal auch mit Glasmosaiken – verzierten Bronzefüßen. Tiffany ließ sich für seine Lampenschirme von vielen verschiedenen Blumen inspirieren: Geranien, Mohnblumen, Klematis, Weihnachtssternen, Wasserlilien, Osterglocken, Tulpen, Pfingstrosen, Kapuzinerkresse, Narzissen, Magnolien, Begonien, Hortensien, Goldregen, Rosen und Apfelblüten. Außerdem finden sich Blauregen, Weinstock-, Kirschbaum- und Bambusblattmotive sowie exotische Früchte wie etwa Ananas. Gewisse Lampenschirme greifen hi-

ciselé, parfois incrusté de mosaïques de verre, qui sont aujourd'hui recherchées par les collectionneurs. Parmi les innombrables fleurs qui ont parsemé ses abat-jour, on reconnaît le géranium, le coquelicot, la clématite, le nénuphar, la jonquille, la tulipe, la pivoine, la capucine, le narcisse, le magnolia, le bégonia, l'hortensia, le cytise, la rose, la fleur de pommier, de cerisier et la feuille de bambou. On trouve aussi de la glycine et des fruits exotiques comme l'ananas. Certains styles d'abat-jour rappellent des périodes historiques célèbres, comme les modèles élisabéthain, vénitien ou russe. Son abat-jour «Libellule» connaît un immense succès et est produit dans toute une gamme de formes, de tailles et de couleurs. Certains abat-jour, parmi les plus complexes, comportent chacun plus d'un millier d'éléments de verre.

La lampe «Lotus» est l'un des ensembles socle/abat-jour en mosaïque de verre les plus splendides et les plus spectaculaires jamais produits par les ateliers Tiffany. Le motif du lotus trouve ses racines dans les civilisations indienne et égyptienne et pour les artistes français de l'Art Nouveau, le lotus est symbole de renaissance. Il ne subsiste aujourd'hui que deux spécimens de ce modèle harmonieux et si finement équilibré. La lampe repose sur un pied en bronze, orné d'un relief de mosaïques vert vif finement ouvragé. Le haut du fût se divise en vingt branches. Les huit branches supérieures sont surmontées d'ampoules protégées par des abat-jour soufflés de verre Favrile chatoyant, évoquant des bourgeons de lotus à peine éclos, rose vif et blanc crémeux. Les branches inférieures portent un abat-jour en mosaïque de verre représentant des fleurs de lotus largement épanouies, colorées de rose, orange et rouge, sur un fond de feuilles vert profond. Cette incroyable lampe est un parfait exemple de l'extraordinaire amour que Tiffany portait à la nature et de son génie pour l'in-

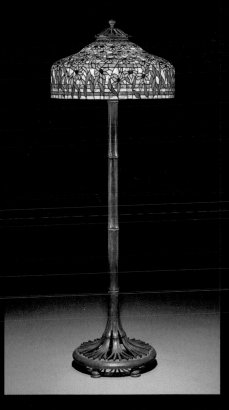

Black-eyed Susan floor lamp with bronze base.
Stehlampe mit Bronzefuß und Rudbeckiadekor.
Lampadaire Rudbeckia avec un pied de bronze.

h: 171 cm. Ø 62.2 cm.
Courtesy Art Focus, Zurich.

lotus represented rebirth. Only three examples of this well-balanced and harmonious work are known to still exist. The lamp has a bronze base covered with finely detailed mosaic tiles of vibrant green. At the top the stalk branches into 20 bronze stems. The top eight stems end in light bulbs covered with blown shades of shimmering Favrile glass, giving the impression of barely-opened lotus buds in radiant pink and soft white. The lower stems hold a leaded glass shade representing lotus flowers in full bloom rendered in pink, orange, and red against a backdrop of striking green leaves. This magnificent lamp aptly displays Tiffany's great love of nature and his genius in vividly interpreting it. It was sold in December 1997 at Christie's auction house in New York for $2,807,500—a record price for a Tiffany lamp. Even at the time it was made, the Lotus lamp was very difficult to produce, and at $750 (in 1906), was Tiffany's most expensive model. Indeed, the studio produced just one Lotus lamp at a time, beginning production of another example only when the prior one had been sold. Other lamps of similar complexity and cost were the Cobweb and the Butterfly, each listed at $500, while the Wisteria and Pond Lily models were priced at $400.

Another Tiffany lamp recently sold at auction is the Peacock centerpiece table lamp, sold in December 1998 by Phillips in New York for $1,872,500. This spectacular lamp, the only one of its kind known to exist, is a masterful combination of shade and gilded bronze base. Although the peacock motif is characteristic of Art Nouveau, it is rare among Tiffany lamps. Rows of peacock feathers adorn the glass shade, beautifully complementing the heart and scallop shapes of the bronze and glass base. Experts believe that Tiffany commissioned the lamp for his own luxurious residence on 72nd Street and Madison Avenue in

storische Stile wie den elisabethanischen, den venezianischen, den russischen und den Empirestil auf. Ungemein beliebt waren auch die Libellen-Lampenschirme (»Dragonfly«) mit ihren schillernden Farben, die in vielen verschiedenen Größen und Formen hergestellt wurden. Manche der komplexeren Lampenschirme setzen sich aus mehr als 1000 Glasstücken zusammen.

Die Lotos-Lampe gehört zu den spektakulärsten und prachtvollsten Kombinationen aus einem bleiverglasten Lampenschirm und einem darauf abgestimmten Lampenfuß, die je in den Tiffany-Studios gefertigt wurden. Das Lotosmotiv hat seine Wurzeln in der ägyptischen und in der indischen Kultur. Für die französischen Art-Nouveau-Künstler repräsentierte die Lotosblume die Wiedergeburt. Von diesem ausgewogenen und harmonischen Lampenmodell sind nur noch zwei Exemplare bekannt. Der Bronzefuß mit seinem detailreichen Mosaikbesatz in pulsierendem Grün verzweigt sich am oberen Rand in 20 Lotosblumenstängel. Die oberen acht Stängel münden in Lampenschirme aus geblasenem schimmerndem Favrile-Glas, die den Eindruck von sich öffnenden Lotosblüten in kraftvollen rosa und sanften weißen Farbtönen entstehen lassen. Die unteren Stängel halten einen bleiverglasten Lampenschirm, der in Rosa, Orange und Rot wiedergegebene Lotosblumen in voller Blüte vor dem Hintergrund sattgrüner Blätter zeigt. In dieser faszinierenden Lampe hat Tiffany seine Liebe zur Schönheit der Natur auf unvergleichlich geniale Art und Weise zum Ausdruck gebracht. Im Dezember 1997 erzielte sie auf einer Auktion bei Christie's in New York 2807500 Dollar – ein Rekordpreis für eine Tiffany-Lampe. Für die Herstellung der Lotos-Lampe war ein außergewöhnlich großer Arbeitsaufwand erforderlich, und sie war 1906 mit 750 Dollar Tiffanys teuerstes Modell. Tatsächlich wurde immer nur jeweils eine Lotos-

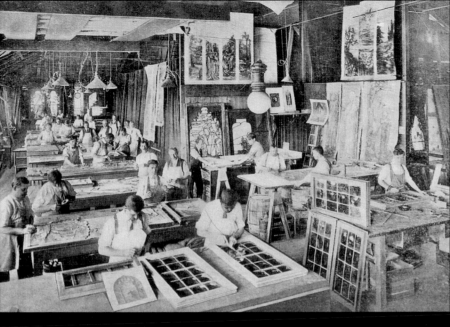

terpréter avec éclat. En décembre 1997, elle est vendue chez Christie's, à New York, pour la somme de 2807500 dollars, prix record pour une lampe Tiffany. Même à l'époque de sa fabrication, la lampe Lotus était très difficile à produire et son prix, 750 dollars en 1906, faisait d'elle le modèle le plus cher des Ateliers. De fait, on n'y produit alors qu'une seule lampe «Lotus» à la fois, et on ne commence la fabrication d'un nouvel exemplaire que lorsque le précédent a été vendu. Il existe d'autres lampes d'une semblable complexité et d'un prix aussi élevé comme la «Toile d'araignée» et le «Papillon», chacune mise au prix de 500 dollars, alors que la «Glycine» et le «Nénuphar» sont vendues à 400 dollars.

Glass shop at Tiffany Studios, c. 1913.
Glasfensteratelier in den Tiffany Studios, um 1913.
Atelier de vitraux des Tiffany Studios, vers 1913.

Private collection.

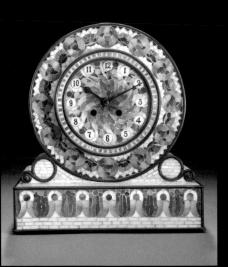

New York, which also served as a showroom. There is no doubt that Tiffany's lamps were designed and assembled by highly trained artisans and superb colorists. Tiffany left the designing of most of the lamps and their bases to the artists working for him; however, every design needed his final approval before it could be put into large-scale production. In 1892, long before women's suffrage in the United States, Tiffany hired his first group of women artisans to work in Tiffany Studios. Two years later he was employing some 50 women. In 1904, Clara Driscoll, one of Tiffany's designers, was said to be the highest paid woman in America at a time when women earned on average 60% less than men. Tiffany had always believed that employing women would ensure a higher quality of artistry in his creations. Yet when Candace Whee-

Lampe hergestellt; die nächste wurde erst dann in Angriff genommen, wenn die Vorgängerin verkauft worden war. Andere, ähnlich komplexe und kostspielige Lampenmodelle waren »Spinnennetz« (»Cobweb«) und »Schmetterling« (»Butterfly«), die für jeweils 500 Dollar angeboten wurden, während die Modelle »Blauregen« (»Wistaria«) und »Teichlilie« (»Pond Lily«) für jeweils 400 Dollar verkauft wurden.

Im Dezember 1998 wurde die prachtvolle Tafelaufsatzlampe »Pfau« (»Peacock«) vom Auktionshaus Phillips in New York für 1872500 Dollar versteigert – der zweithöchste Preis, der bis heute für eine Tiffany-Lampe erreicht wurde. Diese wahrhaft einzigartige Lampe – ein Pendant ist nicht bekannt – stellt ebenfalls eine meisterhafte Kombination aus einem Lampenschirm und einem vergoldeten Bronzefuß dar. Für die französische Art-Nouveau-Bewegung war der Pfau ein charakteristisches Motiv, von Tiffany wurde es jedoch nur selten für seine Lampen verwendet. Die den gläsernen Lampenschirm schmückenden Pfauenfederreihen sind wunderbar auf die Herz- und Muschelformen des aus Bronze und Glas gearbeiteten Fußes abgestimmt. Diese Lampe ließ Tiffany vermutlich für sein luxuriöses Wohnhaus an der 72nd Street/Madison Avenue in Manhattan fertigen, das ihm auch zu Ausstellungszwecken diente.

Tiffanys Lampen wurden von vorzüglich ausgebildeten Fachkräften und hervorragenden Koloristen gestaltet und zusammengesetzt. Tiffany ließ die meisten Lampenschirme und -füße von den Künstlern entwerfen, die für ihn arbeiteten, doch jeder Entwurf musste von ihm selbst gebilligt werden, bevor er in die Produktion ging. 1892, lange bevor die Frauen in den Vereinigten Staaten das Wahlrecht bekamen, stellte Tiffany die ersten Kunsthandwerkerinnen ein. Zwei Jahre später beschäftigte er schon etwa 50 Frauen, und 1904 galt Clara

Autre lampe remarquable, la fabuleuse «Paon», ornement de centre de table, vendue aux enchères à New York par Phillips, en décembre 1998 pour 1872500 dollars. Unique en son genre, elle est d'une beauté saisissante, équilibre magistral entre son abat-jour et son pied en bronze doré. Quoique caractéristique de l'Art Nouveau, le motif du paon est très rare dans les lampes Tiffany. Des rangées de plumes de paon ornent l'abat-jour de verre, et viennent souligner avec élégance les formes de cœur et de coquilles du socle en verre et en bronze. Selon certains experts, Tiffany aurait commandé cette lampe lui-même pour sa luxueuse résidence, à l'angle de 72nd Street et de Madison Avenue, à New York, qui lui servait aussi de salle d'exposition.

Il ne fait aucun doute que le dessin et l'as-

Glassware created by Emile Gallé.
Glasobjekte, entworfen von Emile Gallé.
Objets de verre réalisées par Emile Gallé.

Christie's Images.

Page 26:
Bronze mounted mosaic Favrile glass mantle clock, c. 1910.

Kaminuhr aus Favrilglas-Mosaik in Bronzemontierung, um 1910.

Pendule en mosaïque de verre Favrile avec une sertissure de bronze, vers 1910.

h: 29.8 cm.
Christie's Images.

ler, his partner in L. C. Tiffany & Associated Artists, insisted on receiving credit for her designs, Tiffany dissolved the company and decreed that all designers should work under the business name of Louis C. Tiffany Co. Nevertheless, Clara Driscoll received individual recognition for her Dragonfly lampshade, which won first prize in the 1900 Paris Exhibition.

Nature becomes art: Vases and mosaic murals

Favrile glass is distinguished by ... brilliant or deeply toned colors, usually iridescent like the wings of certain American butterflies, the necks of pigeons and peacocks, the wing covers of various beetles. (L. C. T.)

Glass was at the heart of Tiffany's activities from the 1880's on. In 1898 he published his fifth booklet listing examples of his Favrile glass, and tracing the history of its development back to 3064 bc [!] in Egypt. Surprisingly, this publication also listed all the museums worldwide that owned Tiffany glass at that time. If this disclosure was meant to impress other museums and private buyers, it was certainly successful. Early collectors of Tiffany glass included the Metropolitan Museum of Art in New York, the Imperial Museum in Tokyo and the Smithsonian Institution in Washington D.C. as well as museums in Paris, Berlin, Hamburg, Melbourne, Dublin, Vienna, St. Petersburg, and many other collections throughout Europe. Tiffany continued to publish brochures and lists of his works over the years, as did museums that either purchased his creations or received them as donations from patrons. Tiffany also had an elaborate and elegant showroom in New York in which he was able to exhibit and present his works.

Driscoll, die als Gestalterin für Tiffany arbeitete, als die am höchsten bezahlte Frau in Amerika. Frauen verdienten damals 60% weniger als männliche Arbeitskräfte. Tiffany glaubte, dass Frauen die Qualität seiner Kreationen besser gewährleisten konnten als Männer. Als jedoch Candace Wheeler, seine Partnerin in der Firma Louis C. Tiffany & Associated Artists, auf ihrem Urheberrecht an ihren Entwürfen bestand, löste Tiffany diese Firma auf und verfügte, dass künftig alle Entwürfe seiner Designer unter dem neuen Firmennamen Louis C. Tiffany Co. zusammengefasst werden sollten. Clara Driscoll fand jedoch trotzdem die ihr gebührende Anerkennung für ihren Libellen-Lampenschirm (»Dragonfly«), der auf der Pariser Weltausstellung des Jahres 1900 mit dem ersten Preis ausgezeichnet wurde.

Natur wird zur Kunst: Glasvasen und ein Wandmosaik

Favrile-Glas zeichnet sich durch ... brillante oder intensive, zumeist irisierende Farben aus – wie die Flügel mancher amerikanischer Schmetterlinge, Tauben- und Pfauenhälse, die Deckflügel verschiedener Käfer. (L. C. T.)

Seit den 1880er Jahren stand Glas im Zentrum von Tiffanys Aktivitäten. 1898 veröffentlichte er seine fünfte Broschüre mit Beispielen seines Favrile-Glases. Darin führte er die Geschichte der Glaskunst auf das Jahr 3064 v. Chr. in Ägypten zurück und listete sämtliche Museen in aller Welt auf, die damals Tiffany-Gläser besaßen. Dazu gehörten das Metropolitan Museum of Art in New York, das Kaiserliche Museum in Tokio, die Smithsonian Institution in Washington, D.C., und mehr als zwei Dutzend Sammlungen in ganz Europa. Diese beeindruckende Liste verfehlte ihre Wirkung auf an-

semblage des lampes Tiffany sont l'œuvre d'artisans hautement compétents et de coloristes sans égal. Tiffany confiait la conception de la plupart des lampes et de leurs pieds aux artistes engagés par lui-même. Toutefois, chaque projet devait obtenir son approbation finale avant de suivre la filière de production à grande échelle. En 1892, bien avant le droit de vote des femmes aux Etats-Unis, Tiffany engage dans ses Ateliers sa première équipe de femmes artisans. Deux ans plus tard, elles sont une cinquantaine. En 1904, Clara Driscoll, l'une de ses dessinatrices, est réputée pour être la femme la mieux payée d'Amérique, à une époque où les femmes gagnent en moyenne 60% de moins que les hommes. Tiffany a toujours pensé qu'employer des femmes, assurerait à ses créations une meilleure qualité artistique. Toutefois, quand Candace Wheeler, son associée à la L. C. Tiffany & Associated Artists, insiste pour signer ses propres créations, Tiffany dissout la société et décrète que tous les concepteurs-maquettistes doivent se ranger sous l'appellation Louis C. Tiffany Co. Cependant, Clara Driscoll est personnellement distinguée pour sa lampe «Libellule» qui remporte un premier prix à l'Exposition Universelle de Paris, en 1900.

Enamel floral brooch with amethyst.
Emaillierte Blumenbrosche mit Amethyst.
Broche florale émaillée avec améthyste.

Courtesy Tiffany & Co. Archives.

La nature devient art: vases de verre et mosaïques murals

Le verre Favrile se distingue par des couleurs vives ou profondes, généralement irisées comme les ailes de certains papillons américains, la gorge des pigeons et des paons ou la surface des ailes de divers scarabées. (L. C. T.)

A partir de 1880, le verre est au centre des activités de Tiffany. En 1898, il publie sa cinquième plaquette présentant la liste de ses ver-

Cover of **The Art Work of Louis Comfort Tiffany**.
Only 502 copies of this book, written by art critic
Charles De Kay with Tiffany's cooperation, were
published in 1914 by request of Tiffany's children in
order to record their father's accomplishments.

Einband von »The Art Work of Louis Comfort
Tiffany«. Von diesem Buch, das der Kunstkritiker
Charles De Kay unter Mitwirkung Tiffanys
verfasste, wurden 1914 nur 502 Exemplare
hergestellt. Das auf Wunsch von Tiffanys Kindern
erstellte Opus sollte das Werk ihres Vaters
verewigen.

Couverture du livre «The Art Work of Louis Comfort
Tiffany». Ce livre écrit par le critique d'art Charles
de Kay en collaboration avec Tiffany ne fut publié en
1914 qu'à 502 exemplaires. Les enfants de Tiffany
qui finançaient le projet voulaient immortaliser le
nom leur père par cet ouvrage.

Courtesy Phillips Auctioneers, NY.

Tiffany's creativity in glass was not limited to
stained glass windows and lampshades. In fact,
his vases and other vessels fashioned in glass
rank among the most popular and affordable
objects he ever created. They are also the items
in his oeuvre that most closely resemble the
Art Nouveau glass being produced in Europe by
his contemporary Emile Gallé and other artists
of the School of Nancy that were displayed in
the French salons from 1895 to 1905.

Tiffany was also able to create masterfully
with colored glass on a large scale. He produ-
ced mosaic murals such as the Dream Garden
of 1915, commissioned for the marble lobby of
the Curtis Publishing Company in Philadelphia.
The mural is based on a painting by the Ame-
rican artist Maxfield Parrish, and is the second
largest mosaic Tiffany ever made.

Through the years Tiffany changed the name
of his company several times. In 1885 the firm
was incorporated as the Tiffany Glass Com-
pany, then in 1892, concurrent with the open-
ing of the Corona glass factory, it became
known as Tiffany Glass & Decorating. Around
1893 the glass division split into the Stour-
bridge Glass Company (for glassware) and the
Allied Arts Company (for sheet glass), and in
1900 Allied Arts became Tiffany Studios. Tif-
fany Furnaces was added to the company ros-
ter in 1902 to produce Favrile glassware in vo-
lume. When Tiffany retired from daily
operations in 1919 (though he retained nomi-
nal control over the production lines), the non-
glassware division was reorganized into the Tif-
fany Ecclesiastical Department, which still pro-
duced under the label Tiffany Studios. Tiffany
Furnaces was dissolved in 1924. When Tiffany
Studios officially declared bankruptcy in
1932—one year before Tiffany's death—the
out-standing commissions were completed by
a group of Tiffany artisans under the name
Westminster Memorial Studios. These name

dere Museen und Privatsammler nicht. In späteren Broschüren konnte Tiffany diese Liste ständig erweitern. Viele seiner Arbeiten wurden von Museen angekauft oder gestiftet. Seit 1906 präsentierte Tiffany die in seinen Werkstätten gefertigten Objekte in großzügigen und eleganten Ausstellungsräumen an der Madison Avenue in New York.

Tiffanys Kreativität mit Glas war nicht auf Buntglasfenster und Lampenschirme beschränkt. Zu seinen beliebtesten und auch erschwinglicheren Objekten gehören seine Vasen und Gefäße aus Glas. In seinem Œuvre stellen die Vasen zudem die Objekte dar, die eine besonders enge Verwandtschaft mit dem europäischen Jugendstil zeigen: Émile Gallé und andere Künstler der so genannten Schule von Nancy schufen ähnliche Glasobjekte, die von 1895 bis 1905 in den französischen Salons vorgestellt wurden.

Auch im großen Format konnte Tiffany seine Meisterschaft als Glaskünstler unter Beweis stellen. Er entwarf zum Beispiel Wandmosaiken wie »The Dream Garden« (»Der Traumgarten«; 1915) für die Marmorlobby des Verlagsgebäudes der Curtis Publishing Co. in Philadelphia. »The Dream Garden« beruht auf einem Gemälde des amerikanischen Künstlers Maxfield Parrish und gilt als das zweitgrößte Mosaik der Welt.

Im Laufe der Jahre änderte Tiffany mehrmals den Namen seines Unternehmens. Aus der 1885 gegründeten Tiffany Glass Company wurde 1892, zeitgleich mit der Eröffnung der Glashütte in Corona, die Tiffany Glass & Decorating Company. Um 1893 wurde die Glasmanufaktur in die Stourbridge Glass Company für die Hohlglas- und die Allied Arts Company für die Flachglasproduktion aufgeteilt und 1900 die Allied Arts Company (Tiffany Glass & Decorating Company) in Tiffany Studios umbenannt. 1902 wurde dann noch die Glashütte Tiffany

res Favrile et retraçant l'histoire de ce matériau jusqu'en 3064 avant J-C, en Egypte. Curieusement, on trouve aussi dans cette plaquette la liste de tous les musées du monde qui possèdent, à l'époque, des verres Tiffany. Si le but est ainsi d'impressionner les autres musées et les acheteurs privés, c'est à n'en point douter un succès. Parmi les premiers acquéreurs, on trouve le Metropolitan Museum of Art, le musée Impérial de Tokyo, la Smithsonian Institution de Washington D.C., et plus d'une cinquantaine d'autres collections dans toute l'Europe. Au cours des années, Tiffany continue à publier des brochures et des listes de ses œuvres, comme le font les musées qui achètent ses créations ou les reçoivent de généreux donateurs. A New York, Tiffany possède aussi une élégante salle d'exposition d'un goût raffiné où il peut montrer et mettre en valeur ses œuvres.

Dans le domaine du verre, la créativité de Tiffany ne se limite pas aux vitraux et aux abat-jour. En fait, ses vases et autres récipients d'apparat comptent parmi ses articles les plus populaires et les plus accessibles financièrement. Ce sont aussi les objets les plus proches des verreries de l'Art Nouveau, produites en Europe par son contemporain Emile Gallé et les autres artistes de l'Ecole dite de Nancy, qui participent aux salons français entre 1895 et 1905. Tiffany sait aussi réaliser de grands décors de verre de couleurs. Il produit des mosaïques murales comme le «Dream Garden/Jardin de rêve» de 1915, destiné au vestibule en marbre des Editions Curtis, à Philadelphie. Inspirée d'un tableau de l'Américain Maxfield Parrish, la fresque est considérée comme l'une des plus grandes mosaïques du monde.

Au cours des années, Tiffany change à plusieurs reprises le nom de sa société. En 1885, elle s'appelle la Tiffany Glass Company, puis en 1892, en concurrence avec la nouvelle usine Corona, elle devient la Tiffany Glass and De-

changes reflect Tiffany's organization of his production into "shops" and his recognition of the talent each design and production team brought to the company as a whole.

The man, the dream, and the legend

Infinite, endless labor makes the masterpiece. Color is to the eye as music is to the ear.

(L. C. T.)

Shortly after World War I, the ever-changing wave of artistic tastes as well as the harsh reality of the war turned the tide against Tiffany and his artistic œuvre. Many of his works were removed from their original locations, discarded by their owners, or even vandalized. His creative legacy was brushed aside. Louis Comfort Tiffany's personal fortune (several million dollars at the time of his father's death in 1902) had been depleted as a result of his extravagant lifestyle and the establishment of the Tiffany Foundation. Tiffany Studios declared bankruptcy in 1932, with an inventory of some 200 to 300 tons of glass constituting a palette of "five thousand colors and hues," primarily in the form of ovals about one meter long. Five hundred large crates containing the precious glass were left to an associate, and later to a lawyer. Several decades later the 36,000 sheets of glass were acquired by Dr. Egon Neustadt, who intended to build a Tiffany museum but died before this dream could be realized.

Louis Comfort Tiffany died in relative obscurity on January 17, 1933 in New York, his spectacular works in glass all but forgotten. In 1938 his New York City residence was demolished, and in the same year over 1,000 items remaining from the stock of Tiffany Studios

Furnaces gegründet, um Favrile-Glas in größeren Mengen herstellen zu können, sowie im gleichen Jahr die Stourbridge Glass Company in Tiffany Furnaces umbenannt. 1919 zog sich Tiffany aus dem Alltagsbetrieb seiner Manufakturen zurück, blieb jedoch nominell für die einzelnen Produktionszweige verantwortlich. In diesem Jahr wurde sein Unternehmen in das Tiffany Ecclesiastical Department, das weiterhin unter dem Namen Tiffany-Studios produzierte, und in die Tiffany Furnaces Inc. aufgeteilt. 1924 wurde die Tiffany Furnaces Inc. aufgelöst, und 1932 – ein Jahr vor Tiffanys Tod – meldeten die Tiffany-Studios Konkurs an. Die noch ausstehenden Auftragsarbeiten wurden von einer Gruppe ehemaliger Mitarbeiter der Tiffany-Studios ausgeführt, die zu diesem Zweck die Westminster Memorial Studios gründeten. Auch aus diesen Namensänderungen geht hervor, dass Tiffany sein Unternehmen in einzelne »Werkstätten« mit jeweils auf bestimmte Bereiche spezialisierten Mitarbeitern organisierte, die mit ihren verschiedenen Talenten alle zum Gesamterfolg des Unternehmens beitrugen.

Der Mensch, der Traum und die Legende

Unermüdliche, pausenlose Arbeit bringt das Meisterwerk hervor. Farbe ist für das Auge wie Musik für das Ohr. (L. C. T.)

Mit dem Ende des Ersten Weltkriegs begann Tiffanys Stern zu sinken. Die grausame Realität des Krieges hatte einen neuen Zeitgeist hervorgebracht, der seine Ideen und Kreationen als überholt erscheinen ließ. Viele seiner Werke wurden beseitigt oder sogar zerstört. Tiffany geriet in Vergessenheit. Sein extravaganter Lebensstil und seine Stiftung hatten sein

corating Co. Vers 1893, le département verre se scinde en Stourbridge Glass Co. d'une part et Allied Arts Co., d'autre part. En 1900, Allied Arts Co. prend le nom d'Ateliers Tiffany. Les hauts fourneaux Tiffany s'ajoutent au consortium en 1902, pour la production de verre Favrile en grandes quantités. A partir de 1919, Tiffany se retire progressivement de la production au quotidien, mais garde un contrôle personnel sur les chaînes de production. A cette même époque, la division non-verre est réorganisée, elle devient le Tiffany Ecclesiastical Department, qui continue de produire sous la marque Ateliers Tiffany. En 1924, les hauts-fourneaux sont abandonnés et en 1932, les Ateliers Tiffany se déclarent officiellement en faillite, même si d'importantes commandes en attente sont achevées par un groupe d'anciens artisans Tiffany qui prend le nom d'Ateliers Westminster Memorial. Ces changements d'appellation témoignent du fait que, chez Tiffany, la production est organisée en «cellules», et que chaque équipe de dessinateurs et de fabricants est reconnue et appréciée pour ce qu'elle sait apporter à l'ensemble de l'entreprise.

Tiffany with his granddaughter, Louise Lusk Platt (left), and his nurse Sarah Handley (right), c. 1930.

Tiffany mit seiner Enkelin Louise Lusk Platt (links) und seiner Pflegerin Sarah Handley (rechts), um 1930.

Tiffany avec sa petite-fille Louise Lusk Platt (à gauche) et son infirmière Sarah Handley (à droite), vers 1930.

Courtesy Alastair Duncan, NY.

L'homme, le rêve et la légende

Seul un travail permanent, infini, fait le chef-d'œuvre. La couleur est à l'œil ce que la musique est à l'oreille. (L. C. T.)

Peu après la fin de la Première Guerre mondiale, l'évolution inévitable des goûts artistiques, ainsi que les dures réalités de la guerre, se retournent contre Tiffany et son œuvre. Nombre de ses réalisations sont retirées de leur emplacement d'origine, mises au rebut par leur propriétaire ou même vandalisées. L'apport créatif de Tiffany est sous la forme d'ovales d'environ un mètre de long. Cinq cents

were auctioned off. It was only in the late 1950's, as pioneers of modern design were being rediscovered, that interest in Tiffany's work was renewed. In 1964 Robert Koch's book Louis C. Tiffany, Rebel in Glass was published, and the Art Nouveau movement enjoyed a surge of popularity as a result. Today the interest in Tiffany's creations and aesthetic is at an all-time high. Louis Comfort Tiffany's life was devoted to his "quest of beauty," and his quest was gloriously successful: No American artist before or since has enjoyed such a universal reputation for versatility, creative genius and uniqueness of vision. The name Tiffany is once again associated with luxury, beauty, color and glamour as it was 100 years ago, and more than ever before, is regarded as an integral part of Art Nouveau.

Vermögen, das 1902, nach dem Tod seines Vaters, mehrere Millionen Dollar betrug, aufgezehrt. 1932 mussten die Tiffany-Studios Konkurs anmelden. Das Inventar bestand aus 200 bis 300 Tonnen Glas in »5000 Farben und Farbtönen«, hauptsächlich in Form ovaler, etwa drei Fuß (ungefähr einen Meter) langer Scheiben. In ungefähr 500 großen Kisten wurden die wertvollen Gläser zunächst einem Geschäftspartner und später einem Anwalt überlassen. Nachdem mehrere Jahrzehnte vergangen waren, wurden die 36000 Glasplatten von Egon Neustadt für sein geplantes Tiffany-Museum erworben.

Louis Comfort Tiffany starb am 17. Januar 1933 in New York. 1938 wurde sein Wohnsitz in New York City abgerissen, und im selben Jahr wurden 1000 Objekte aus dem Lager der Tiffany-Studios versteigert. Erst als man in den 1950er Jahren die Pioniere des modernen Designs wieder entdeckte, wurde auch das Interesse an seinem Werk erneut geweckt. 1964 veröffentlichte Robert Koch sein Buch »Louis C. Tiffany, Rebel in Glass« und löste damit eine neue Welle der Begeisterung für den Jugendstil aus. Heute ist das Interesse an Tiffanys Kreationen und seiner Ästhetik größer als je zuvor. Wie vor 100 Jahren wird sein Name wieder mit Luxus, Schönheit, Farbe und Glamour assoziiert, und sein Werk wird mehr denn je als beispielhaft für den Jugendstil betrachtet.

STVDIOS

énormes caisses contenant ce verre précieux sont remises à l'un des associés, puis à un avocat. Quelques dizaines d'années après, les 36000 plaques de verre sont achetées par le Dr Egon Neustadt, qui se propose de fonder un musée Tiffany.

Louis Comfort Tiffany meurt dans l'obscurité, le 17 janvier 1933, à New York. Ses extraordinaires verreries sont presque tombées dans l'oubli. En 1938, sa résidence new-yorkaise est démolie. La même année, plus de 1000 objets du stock des Ateliers sont dispersés aux enchères. Il faudra attendre les années 1950, et la redécouverte des pionniers du design moderne, pour que renaisse l'intérêt pour son œuvre. En 1964, avec la publication de l'ouvrage de Robert Koch, «Louis C. Tiffany, le rebelle du verre», le mouvement Art Nouveau connaît un regain de popularité. Aujourd'hui, l'intérêt pour les créations et l'esthétique de Tiffany bat son plein. Dans sa «Quête de la beauté», longue d'un demi-siècle, Tiffany a su transcender sa recherche de notoriété en grand art. Aucun artiste américain avant lui, et aucun depuis, n'a connu une telle réputation à l'échelle mondiale, pour la multiplicité de ses talents, sa créativité et son point de vue visionnaire. A nouveau, le nom de Tiffany se trouve associé à l'idée de luxe, de beauté, de couleur, de séduction, et plus que jamais, il demeure partie essentielle de l'Art Nouveau.

A Tiffany Studios logo, c. 1905.
Logo der Tiffany Studios, um 1905.
Logo des Tiffany Studios, vers 1905

Private collection.

Lamps

Lampen / Lampes

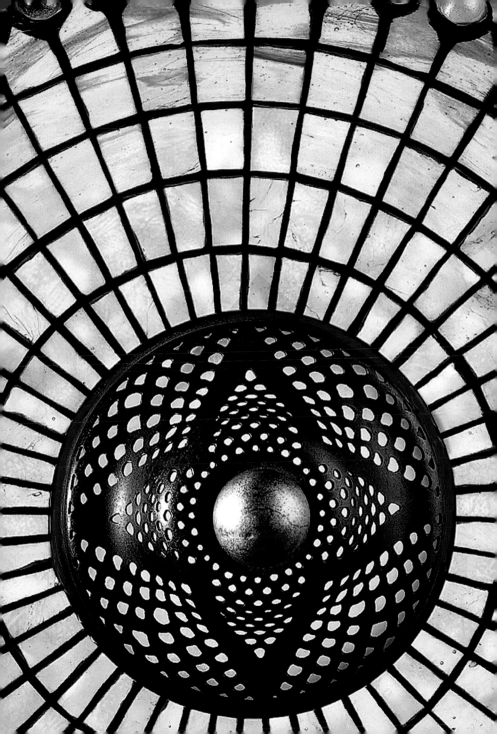

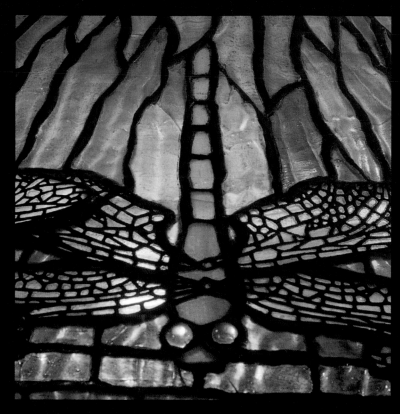

**Table lamp with drophead blue-eyed
dragonflies (detail), c. 1900**
Courtesy Macklowe Gallery, NY.

Page 36/37:
**Geometric leaded and Favrile glass
and bronze table lamp (detail), c. 1900**
h: 71.1 cm. Ø 55.9 cm.
Christie's Images.

Drophead dragonfly table lamp, c. 1900
h: 71.7 cm. Ø 55.9 cm.
Christie's Images.

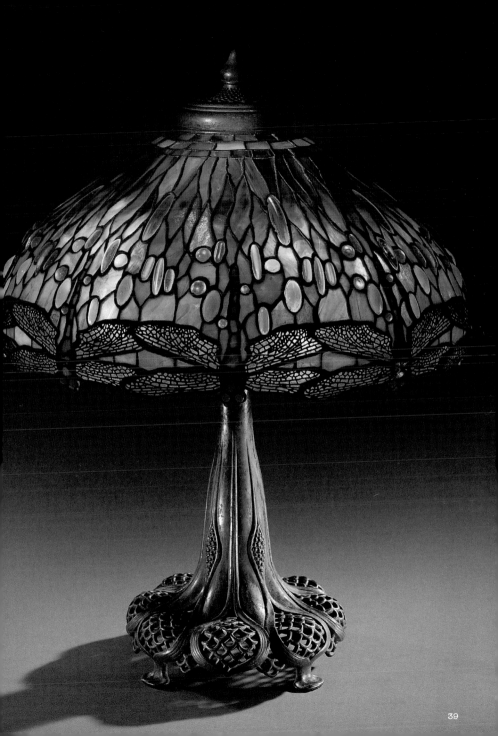

Double poinsettia table lamp, c. 1910
Ø 55.9 cm.
Courtesy Macklowe Gallery, NY.

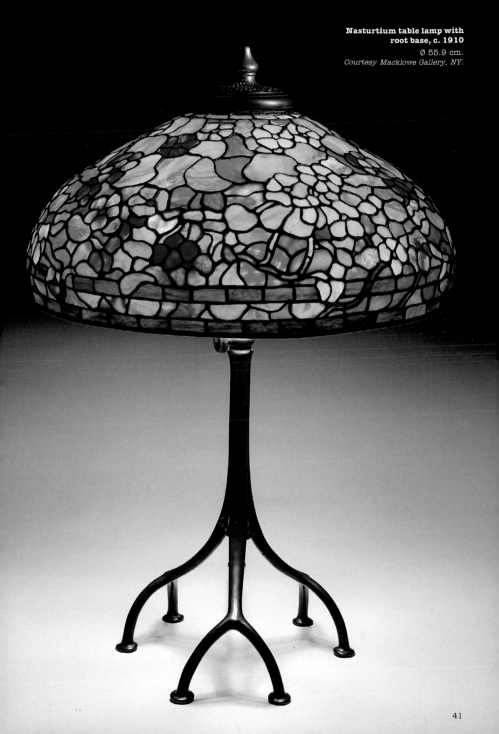

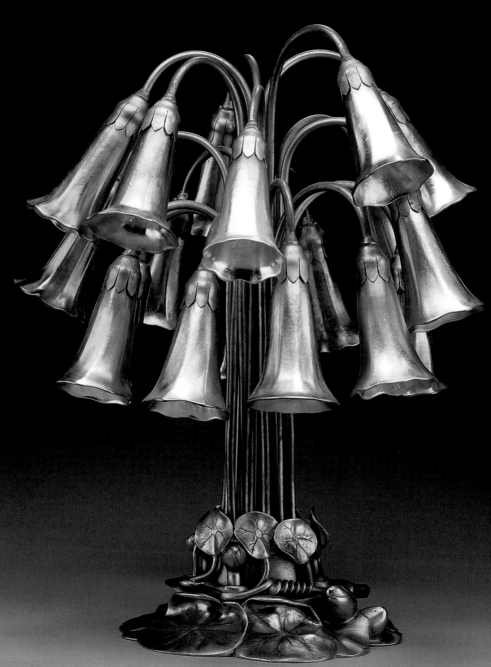

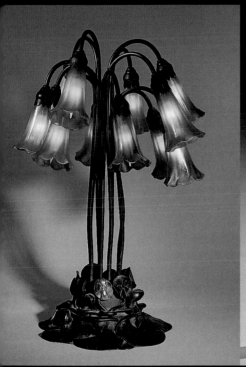

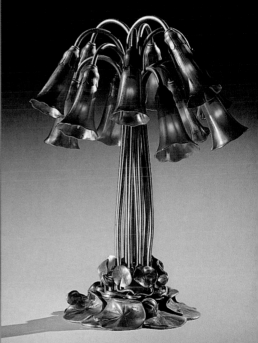

10-light lily lamp, 1900–1910
h: 54.9 cm.
Courtesy Art Focus, Zurich.

12-light lily lamp, 1902–1910
h: 53.3 cm.
Courtesy Phillips Auctioneers, NY.

18-light lily table lamp, c. 1900–1910
h: 52.1 cm.
Christie's Images.

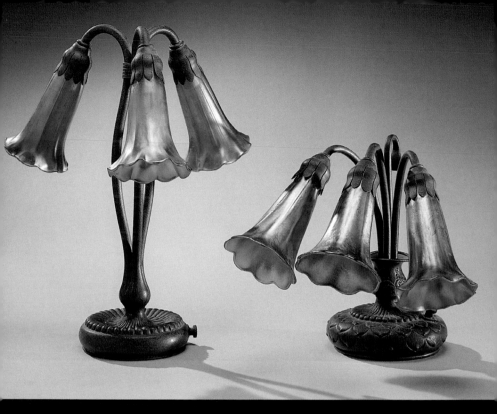

Pair of 3-light lily desk lamps, c. 1905–1908
h: 32.8 cm. 21.5 cm.
Courtesy Phillips Auctioneers, NY.

**7-light lily table lamp with
bronze lilypad base, c. 1905**
h: 57.1 cm.
Courtesy Ophir Gallery, Englewood, NJ.

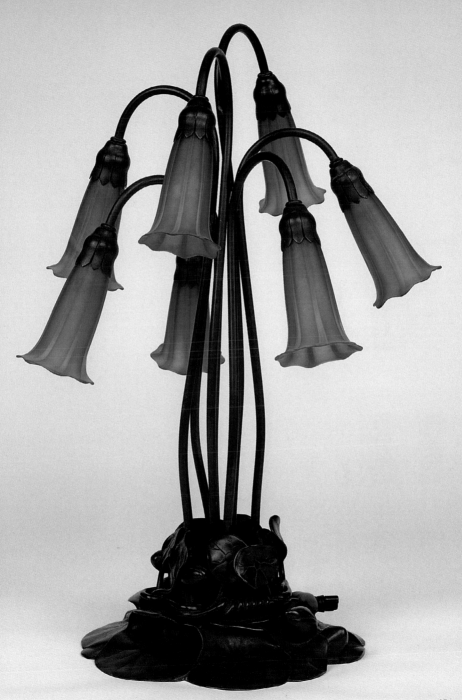

Spider table lamp, c. 1900–1910
h: 53.3 cm. Ø 44.2 cm.
Christie's Images.

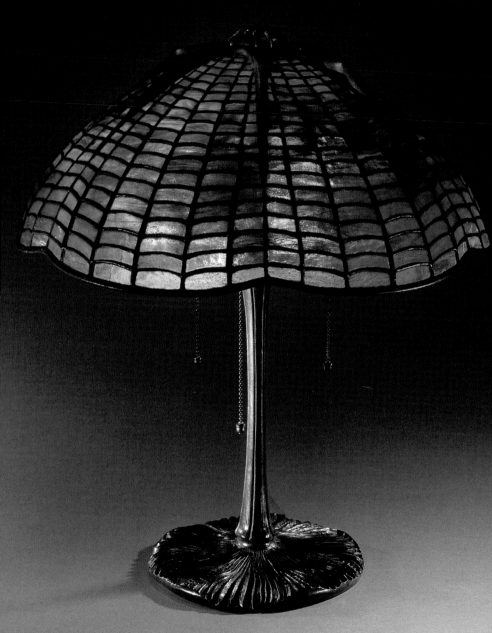

Pond lily table lamp, c. 1900–1905
h: 68.5 cm. Ø 52.1 cm.
Christie's Images.

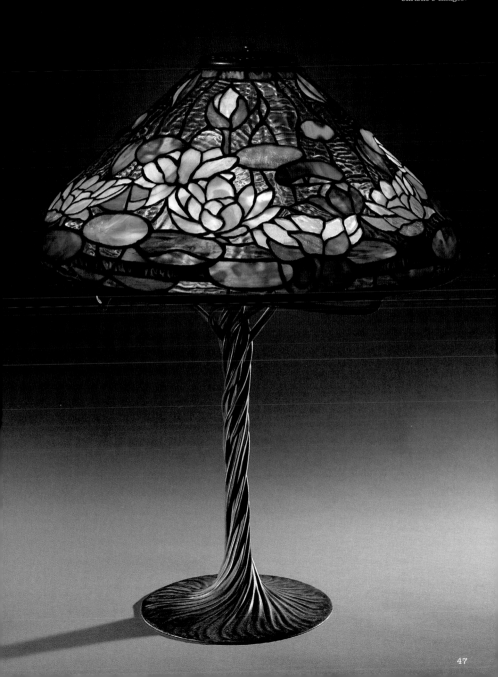

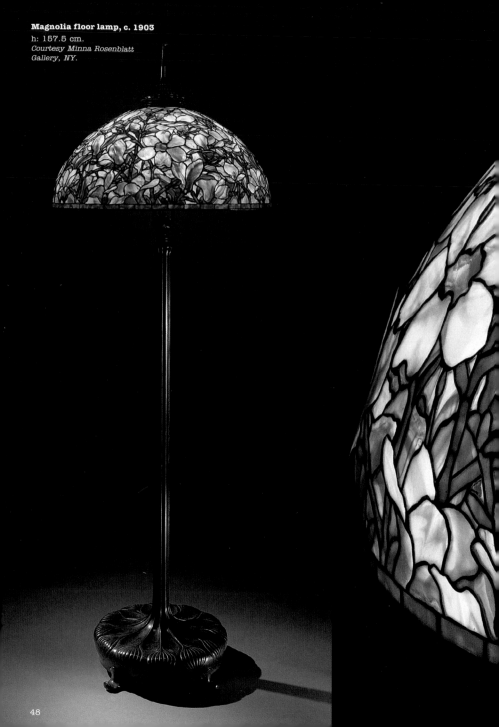

Magnolia floor lamp, c. 1903

h: 157.5 cm.
*Courtesy Minna Rosenblatt
Gallery, NY.*

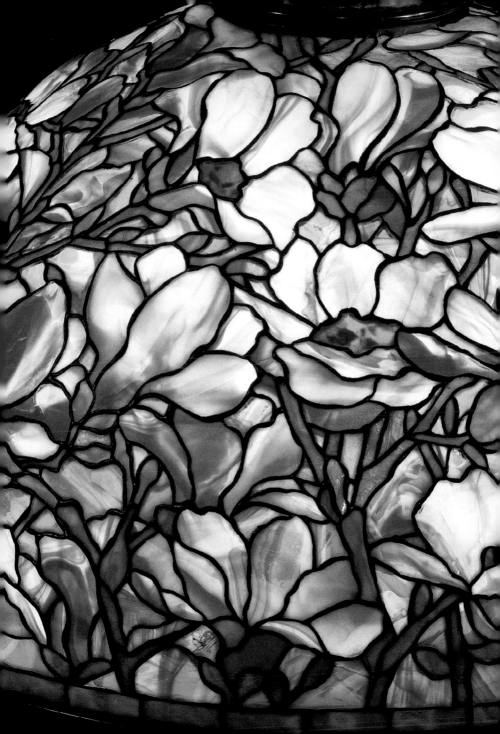

Spreading cherry table lamp, c. 1899–1920
h: 74.9 cm. Ø 63.5 cm.
Courtesy Minna Rosenblatt Gallery, NY

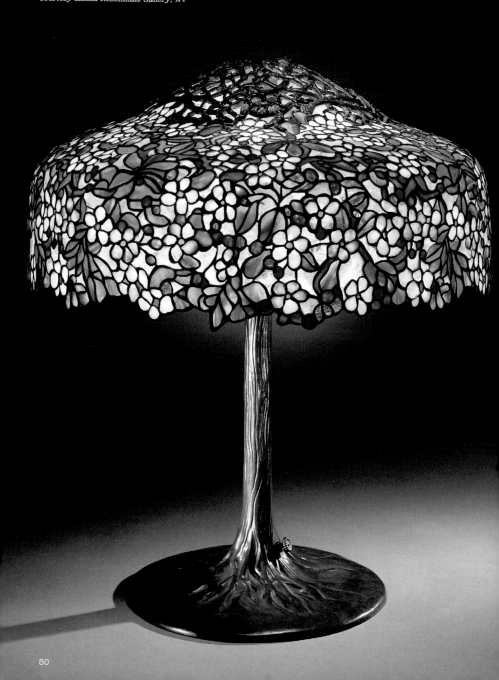

Wisteria table lamp, c. 1902
h: 71.1 cm. Ø 47 cm.
Courtesy Art Focus, Zurich

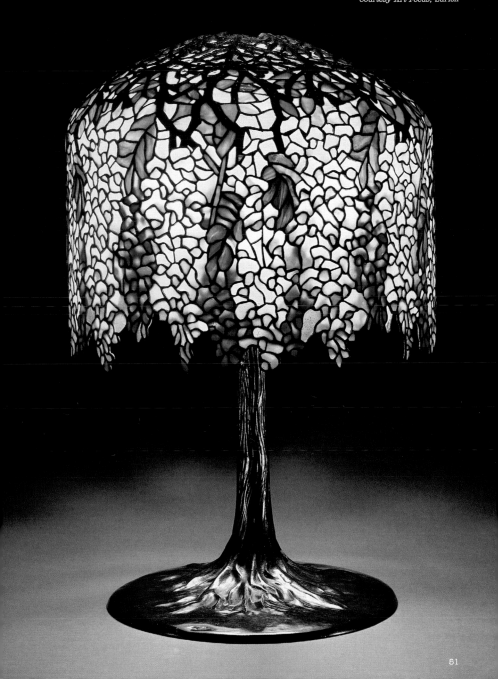

Elaborate grape table lamp, c. 1900-1905
h: 53.3 cm.
Courtesy Lillian Nassau Gallery, NY.

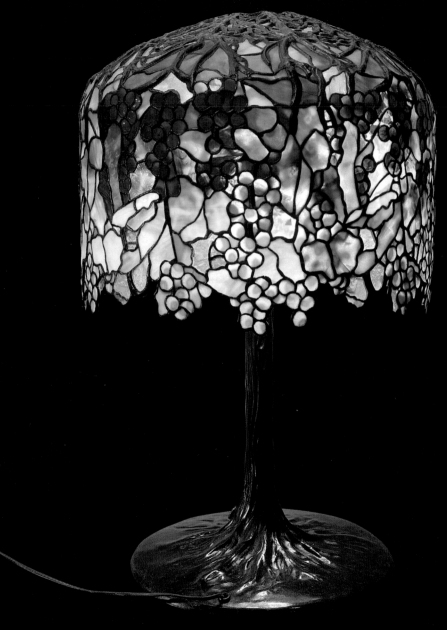

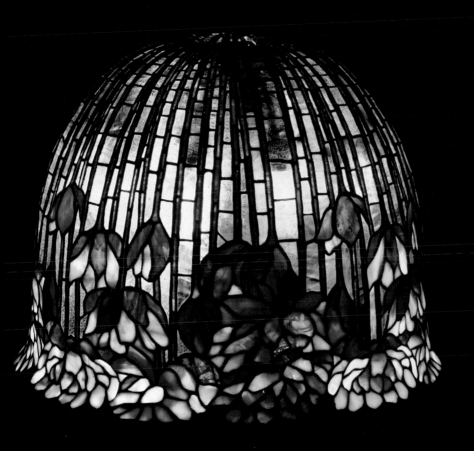

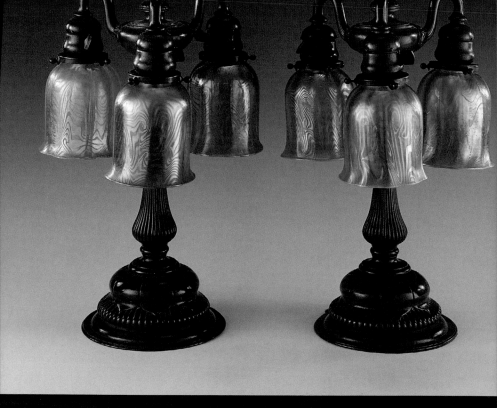

Pair of desk lamps, c. 1910
h: 41.9 cm.
Courtesy Art Focus, Zurich.

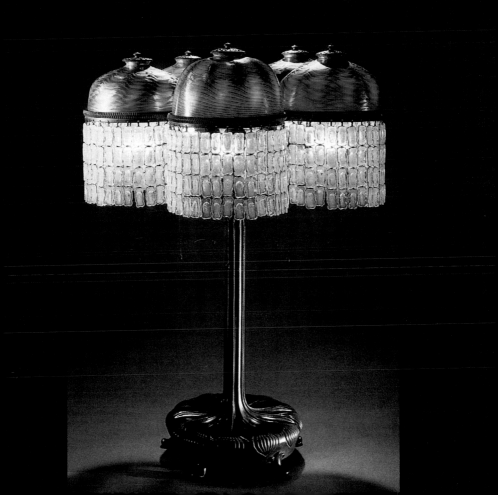

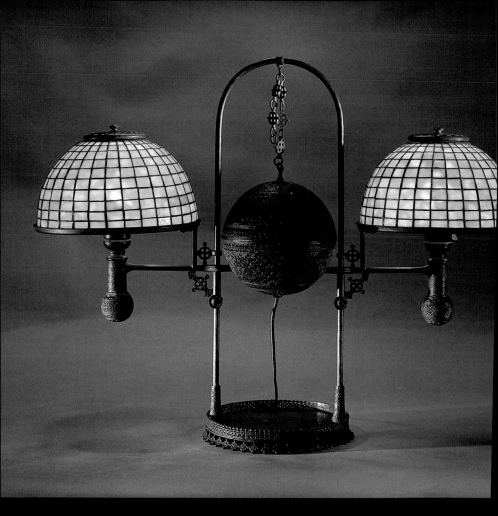

Double reading lamp
with Moorish shades, c. 1898

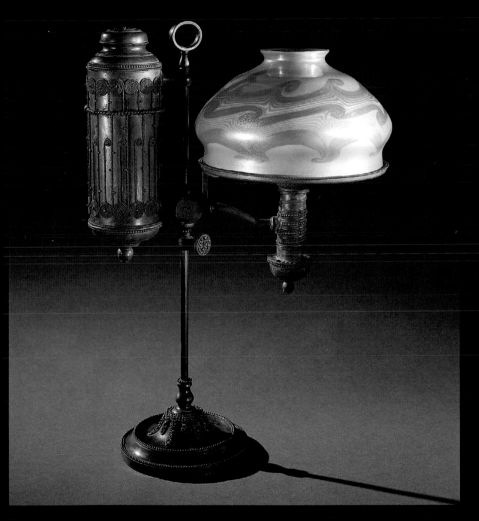

Reading lamp, c. 1900
h: 61 cm. Ø 29 cm.
Courtesy Phillips Auctioneers, NY.

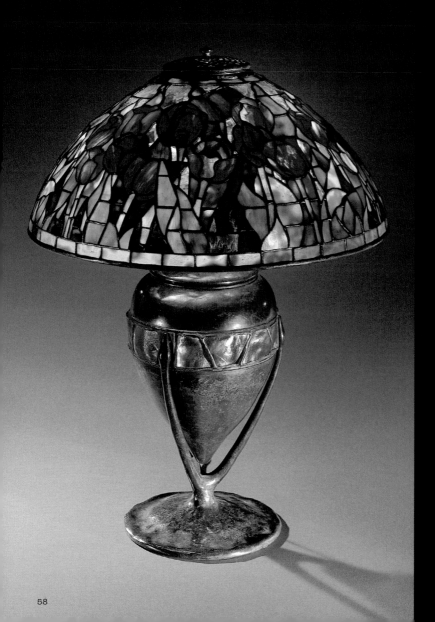

Tulip table lamp, 1906
h: 57.1 cm. Ø 40.6 cm.
Christie's Images.

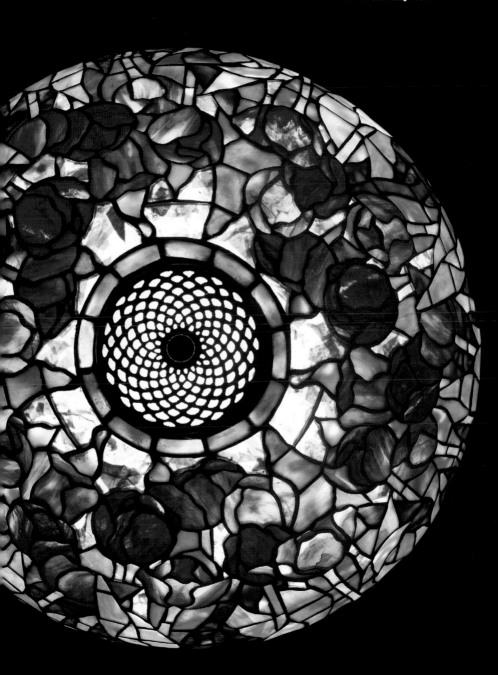

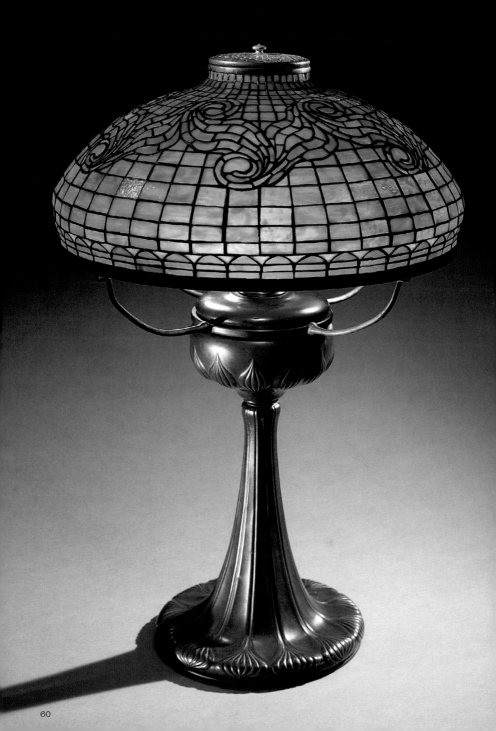

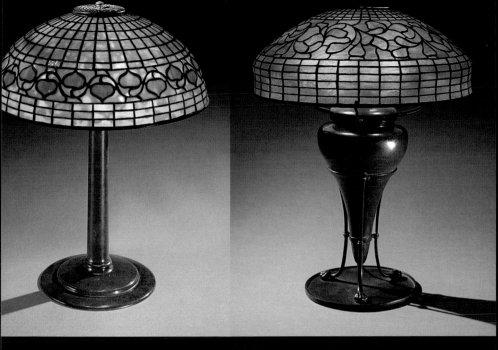

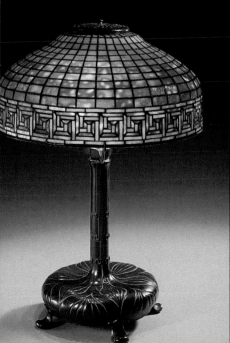

Top left:
Acorn table lamp, c. 1910
h: 58.4 cm.
Courtesy Phillips Auctioneers, NY.

Top right:
Swirling leaf table lamp, c. 1905
h: 71 cm.
Courtesy Phillips Auctioneers, NY.

Bottom:
Greek key table lamp, c. 1907
h: 45.7 cm.
Courtesy Macklowe Gallery, NY.

Page 60:
Tyler table lamp, c. 1905–1907
h: 63.5 cm. Ø 45.8 cm.
Private collection.

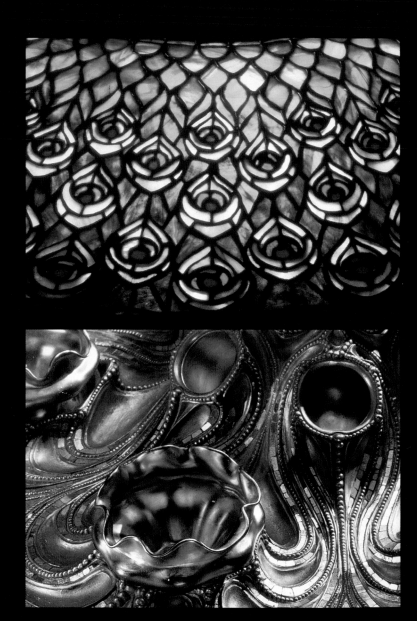

Peacock centerpiece table lamp, c. 1898
Details of shade and base

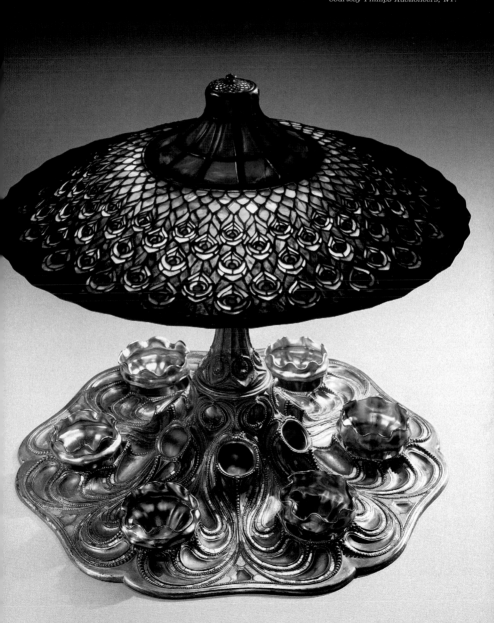

**One-of-a-kind peacock centerpiece
table lamp, c. 1898**

h: 61 cm. Ø (shade and base) 66 cm.
Courtesy Phillips Auctioneers, NY.

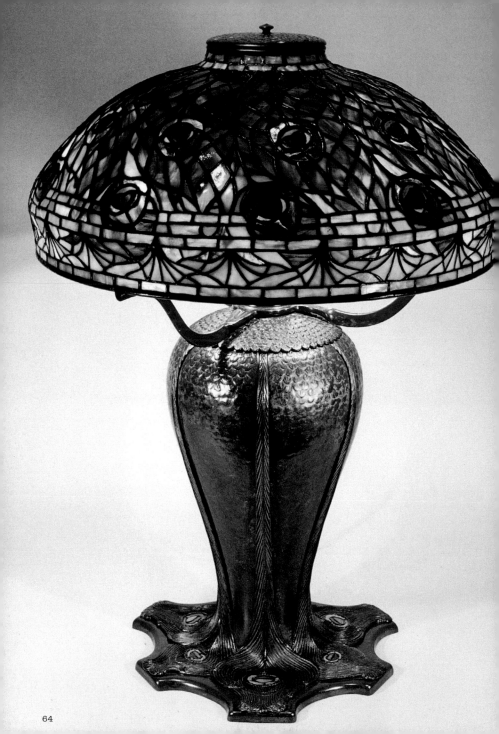

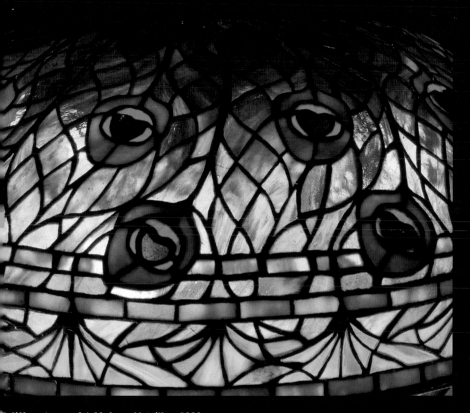

A different peacock table lamp (detail), c. 1900
h: 45.7 cm.
Courtesy Macklowe Gallery, NY.

Peacock table lamp, c. 1905
h: 45.7 cm.
Courtesy Macklowe Gallery, NY.

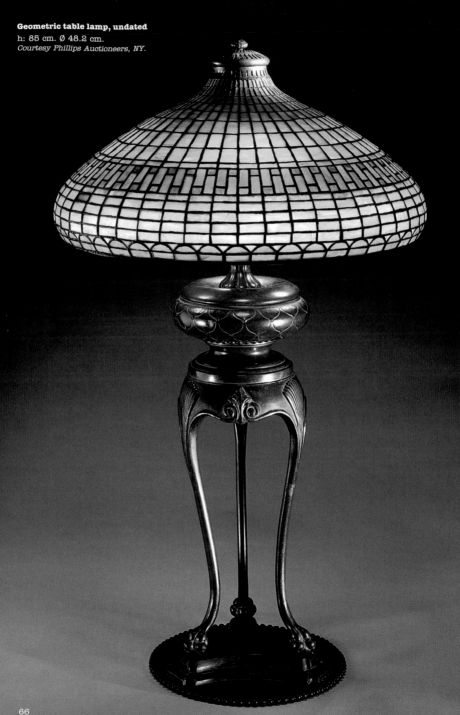

Geometric table lamp, undated
h: 85 cm. Ø 48.2 cm.
Courtesy Phillips Auctioneers, NY.

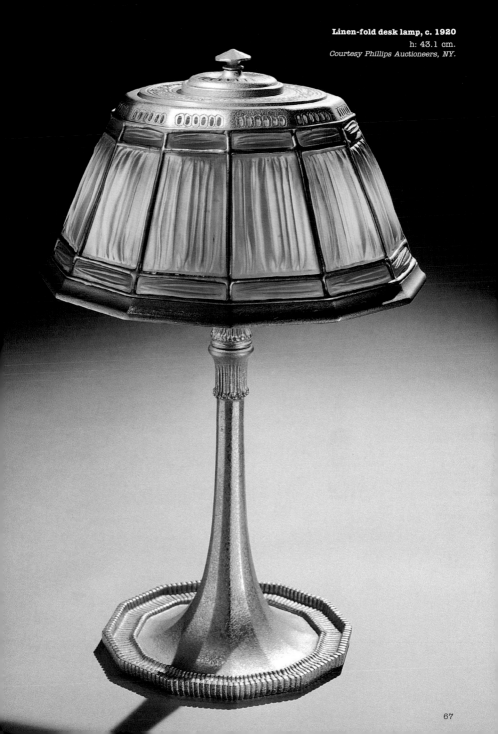

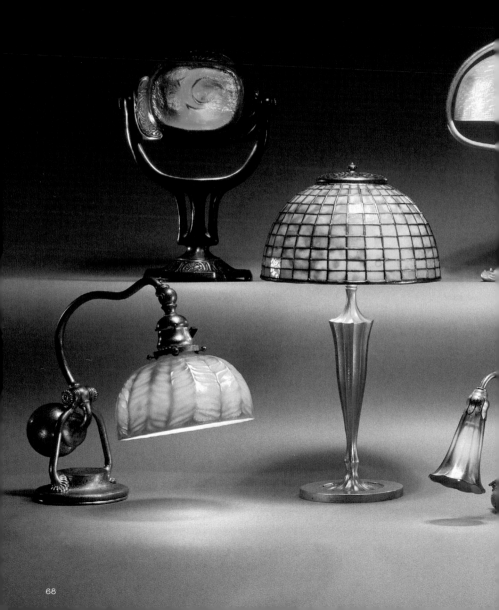

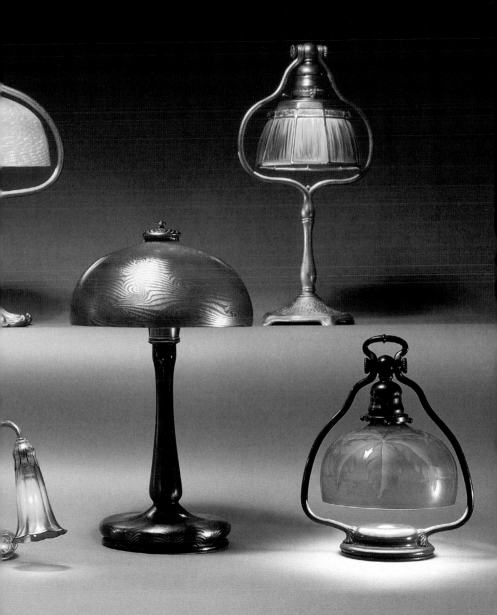

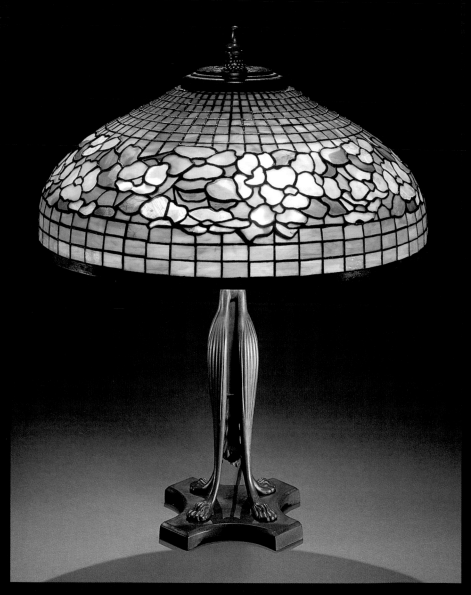

Belted dogwood table lamp, c. 1905
h: 74 cm. Ø 51 cm.
Courtesy Phillips Auctioneers, NY.

Belted dogwood table lamp, c. 1905
h: 40.6 cm.
Courtesy Macklowe Gallery, NY.

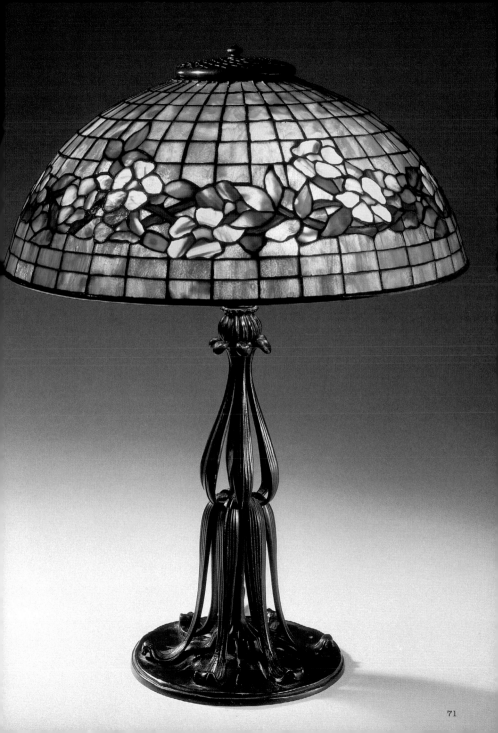

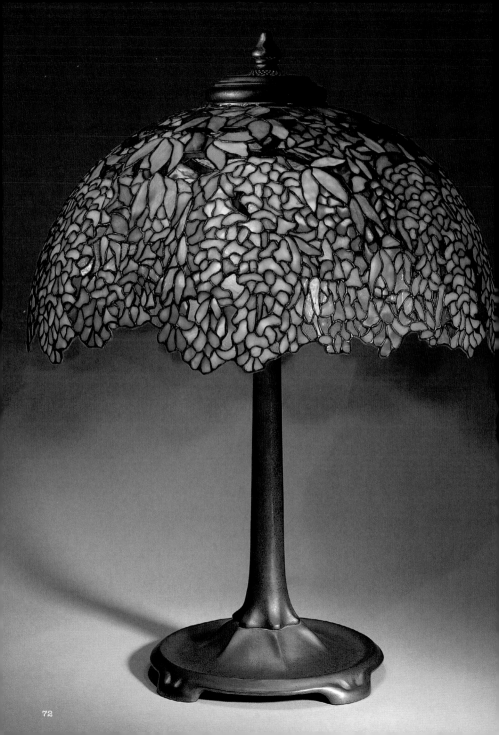

Detail of the lamp shade

Laburnum table lamp, c. 1900–1910
h: 73.7 cm. Ø 54.6 cm.
Courtesy Art Focus, Zurich.

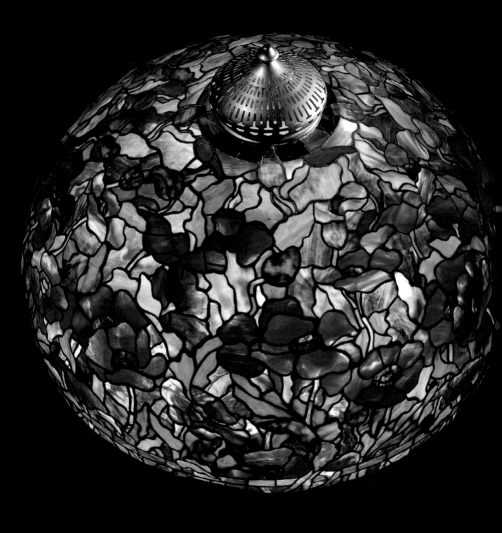

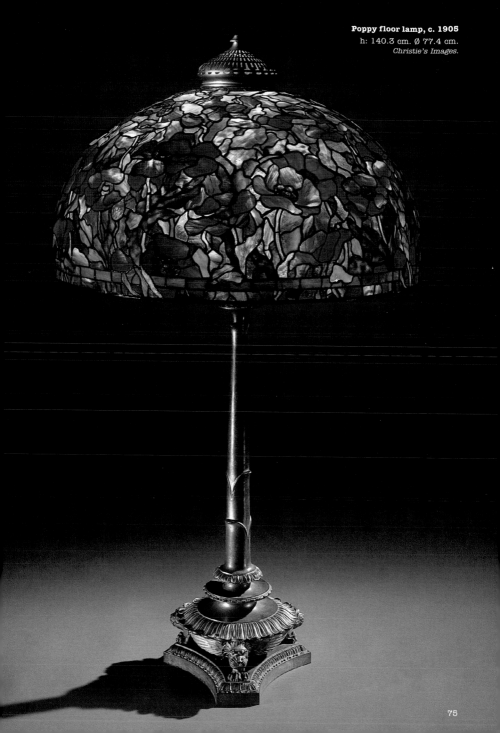

Poppy floor lamp, c. 1905
h: 140.3 cm. Ø 77.4 cm.
Christie's Images.

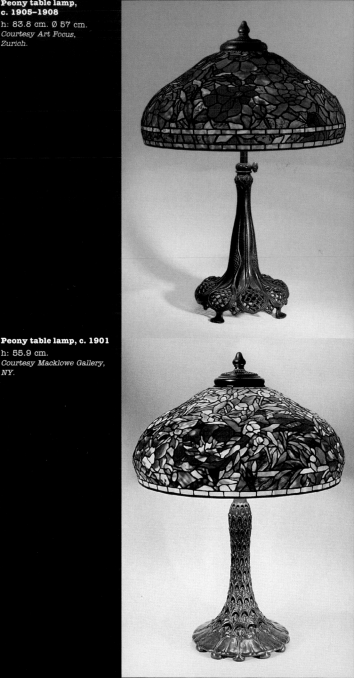

Peony table lamp, c. 1905–1908

h: 83.8 cm. Ø 57 cm.
Courtesy Art Focus, Zurich.

Peony table lamp, c. 1901

h: 55.9 cm.
Courtesy Macklowe Gallery, NY.

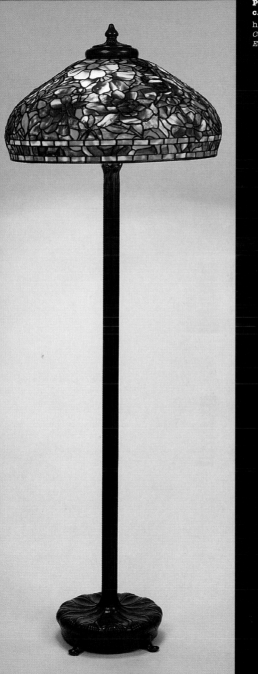

Peony floor lamp, c. 1900–1910

h: 162.6 cm.
*Courtesy Ophir Gallery,
Englewood, NJ.*

Fruit table lamp, c. 1900–1915
h: 73 cm. Ø 61 cm.
Christie's Images.

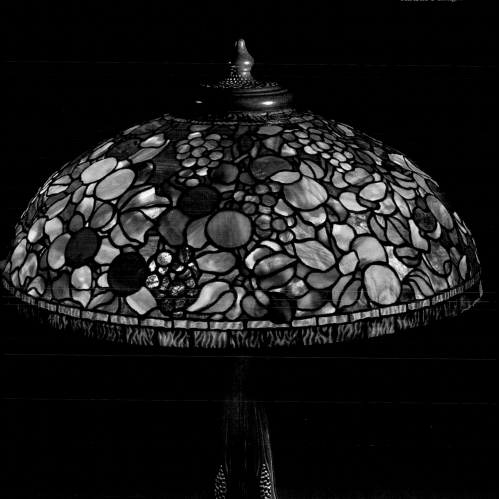

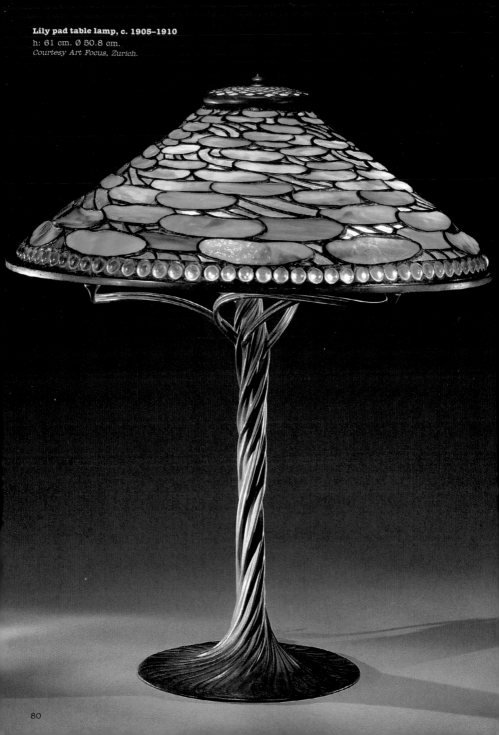

Lily pad table lamp, c. 1905–1910
h: 61 cm. Ø 50.8 cm.
Courtesy Art Focus, Zurich.

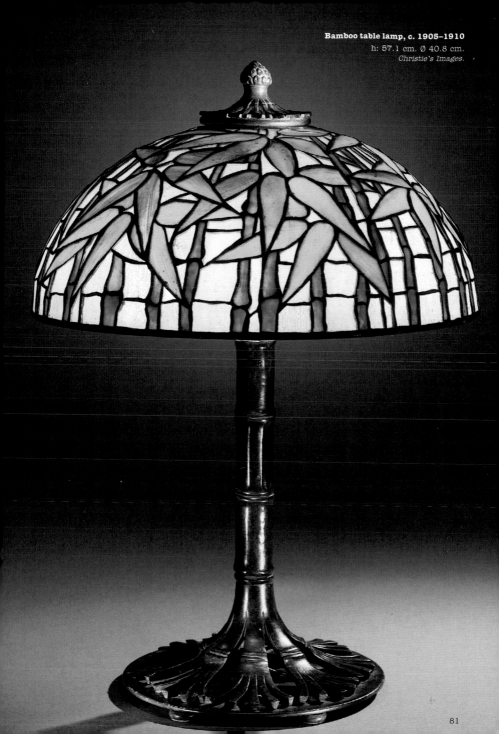

Bamboo table lamp, c. 1905–1910
h: 57.1 cm. Ø 40.8 cm.
Christie's Images.

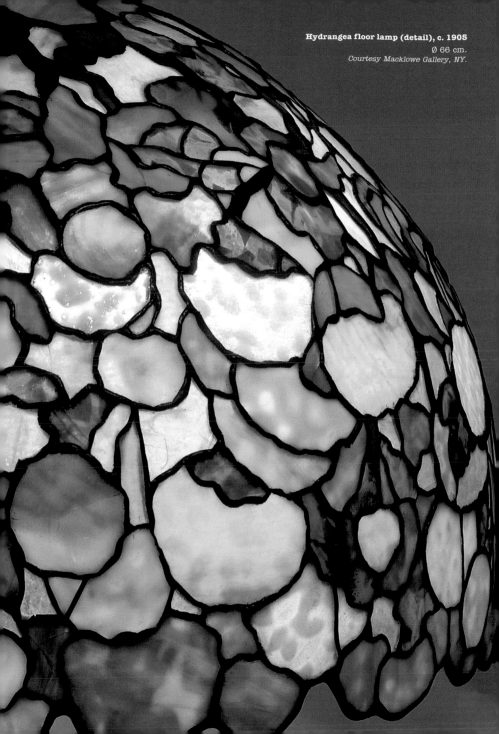

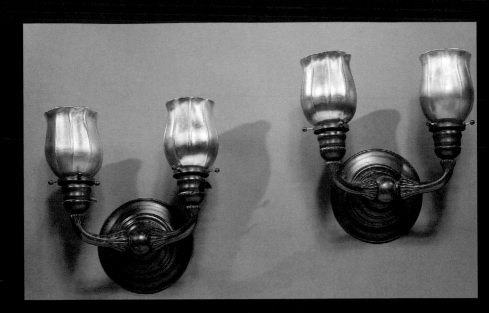

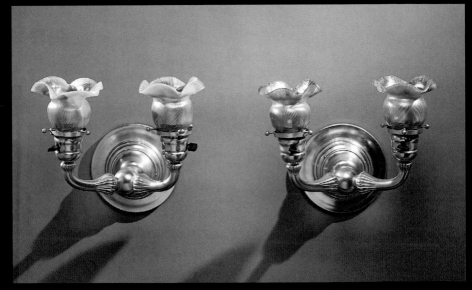

Top:
Pair of tulip-shade sconces, c. 1910
h: 30.5 cm. w: 32 cm.
Courtesy Phillips Auctioneers, NY.

Bottom:
Pair of sconces, c. 1910
h: 45.7 cm.
Courtesy Phillips Auctioneers, NY.

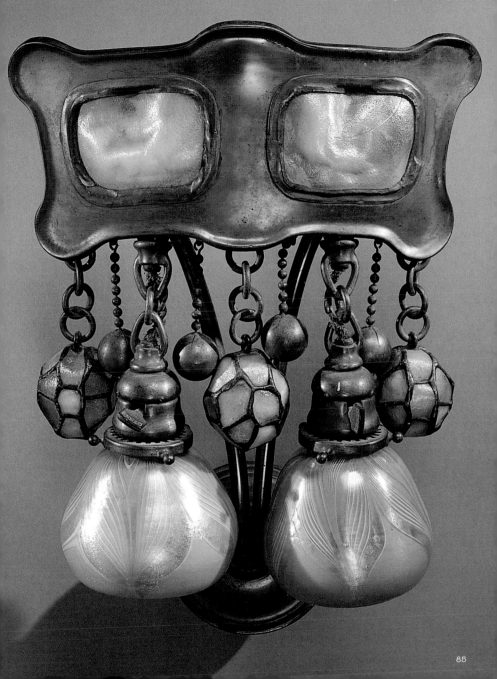

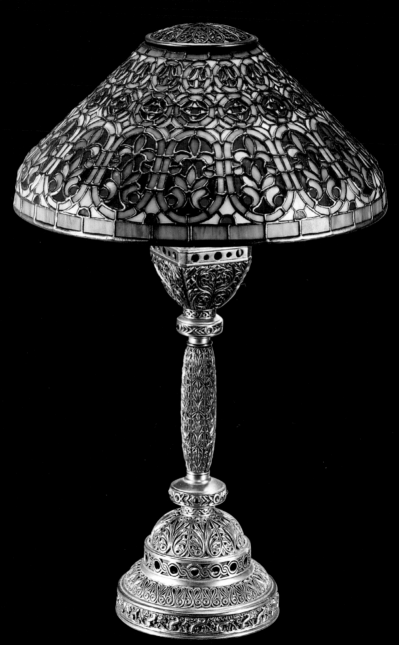

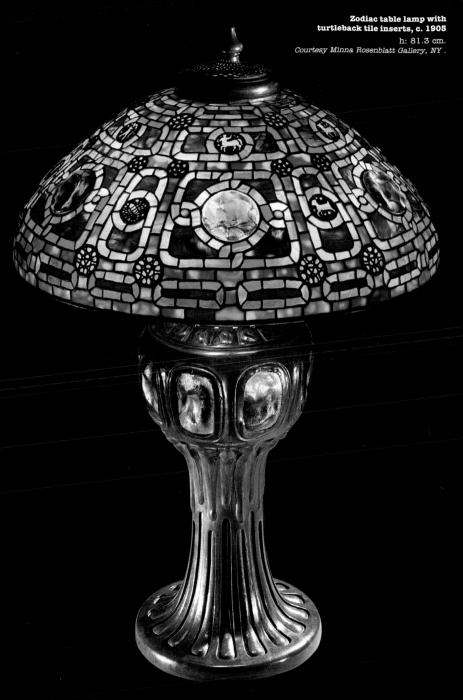

**Zodiac table lamp with
turtleback tile inserts, c. 1905**
h: 81.3 cm.
Courtesy Minna Rosenblatt Gallery, NY.

Peony border floor lamp, c. 1910

h: 198.1 cm. Ø 61 cm.
Courtesy Art Focus, Zurich.

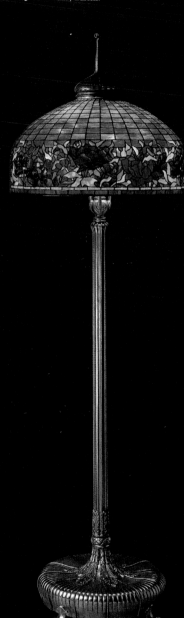

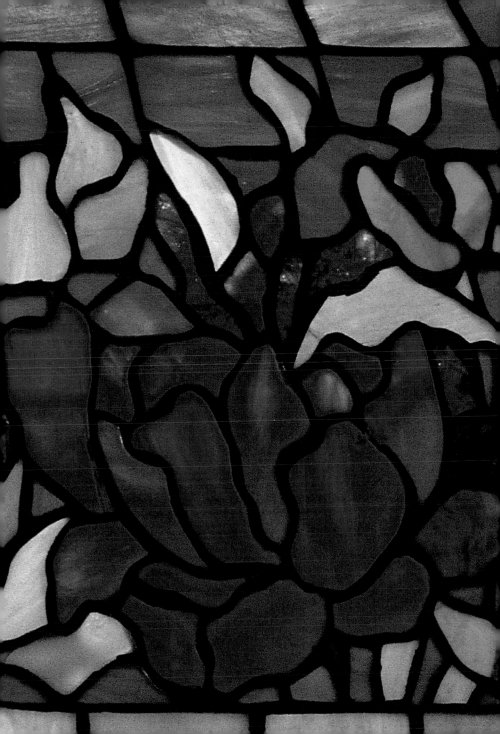

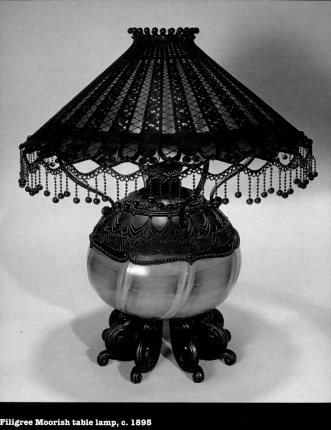

Filigree Moorish table lamp, c. 1895

h: 40.6 cm.

Courtesy Marchese & Co., Santa Barbara, CA.

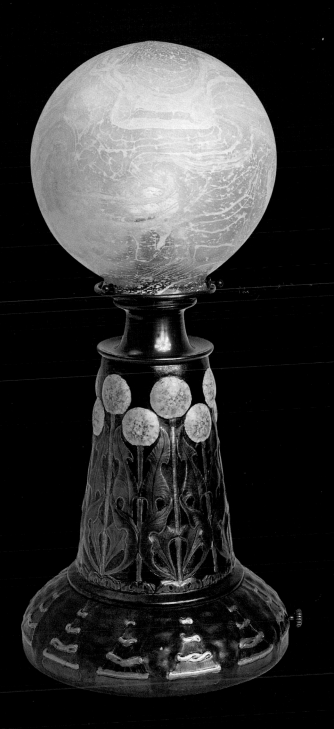

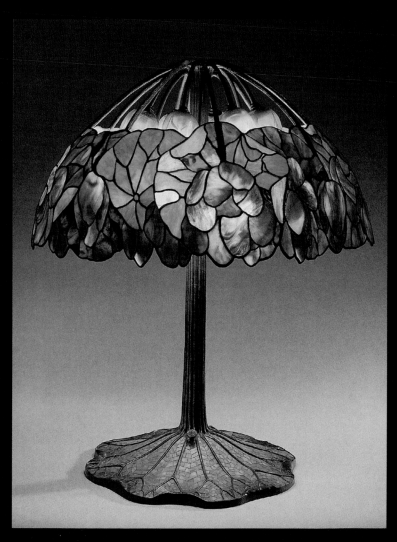

Green lotus lamp, c. 1900–1910
h: 86.4 cm. Ø 63.5 cm.
Private collection.

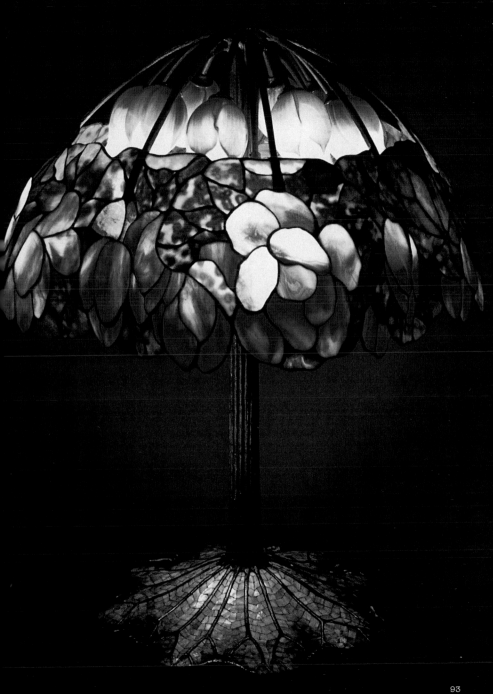

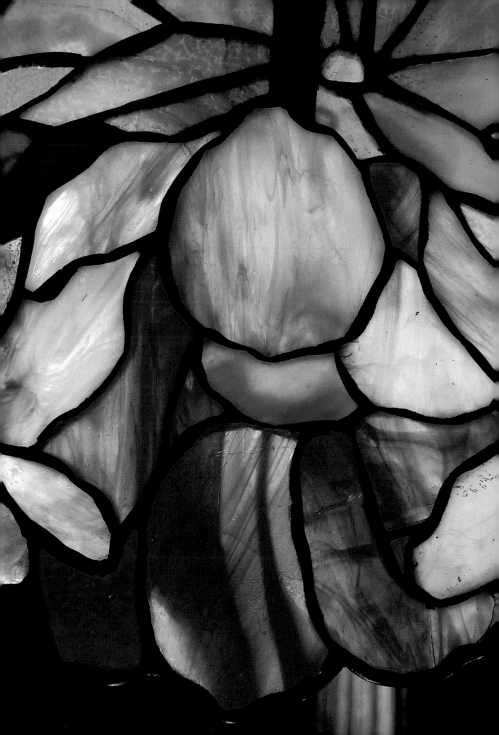

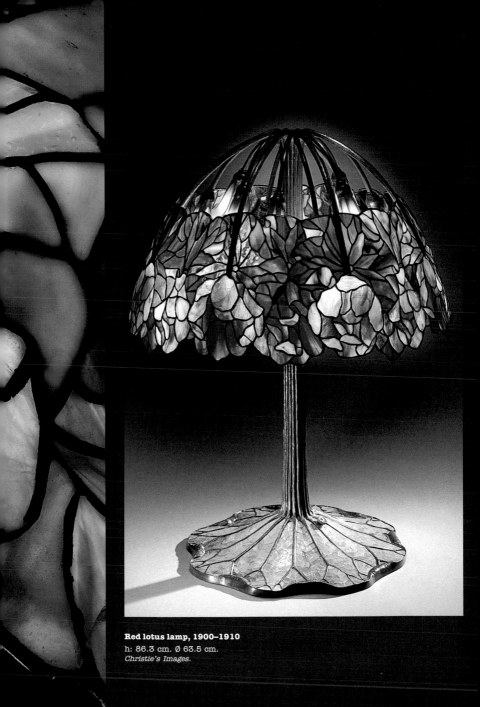

Red lotus lamp, 1900–1910

h: 86.3 cm. Ø 63.5 cm.
Christie's Images.

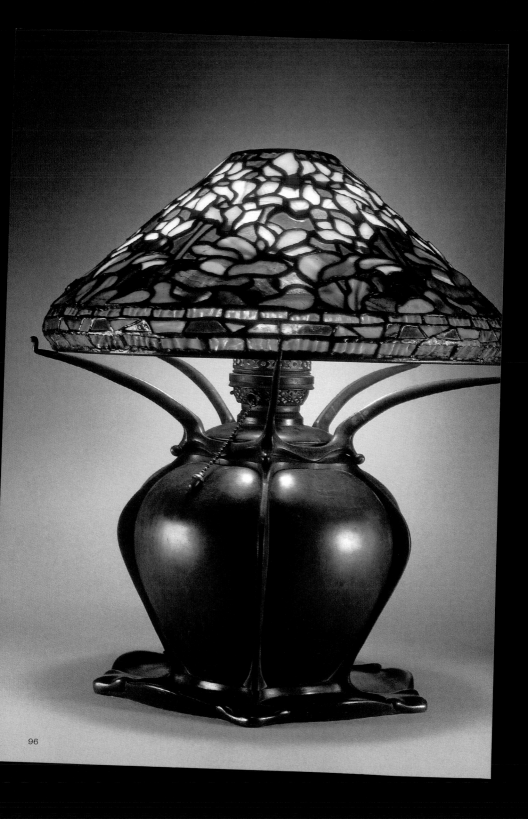

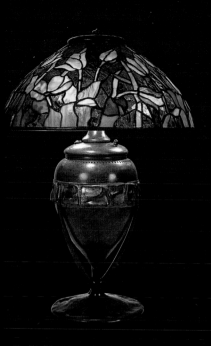

Wild rose border table lamp, c. 1910–1915
h: 54.6 cm. Ø 40.6 cm.
Courtesy Phillips Auctioneers, NY.

Tulip table lamp, c. 1905
h: 40.6 cm.
Courtesy Ophir Gallery, Englewood, NJ.

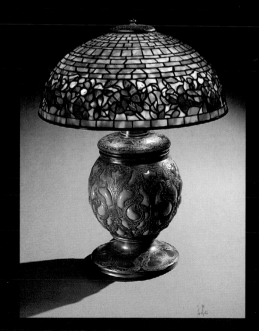

Cyclamen table lamp, c. 1903
h: 43.2 cm.
Courtesy Macklowe Gallery, NY.

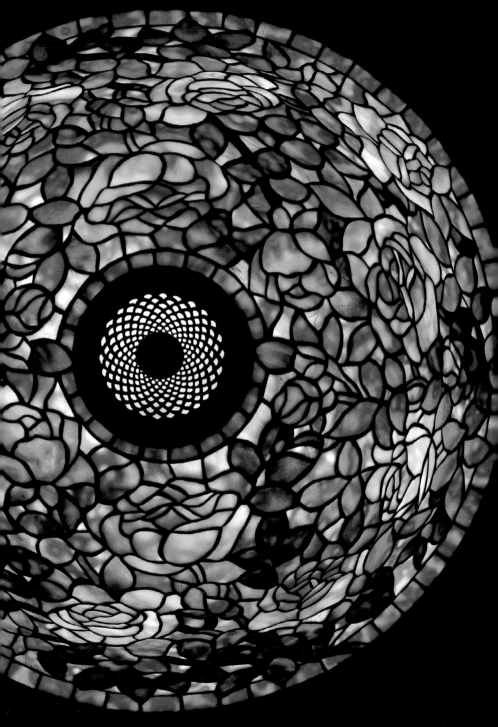

Rose table lamp, c. 1915
h: 80 cm. Ø 62.9 cm.
Christie's Images.

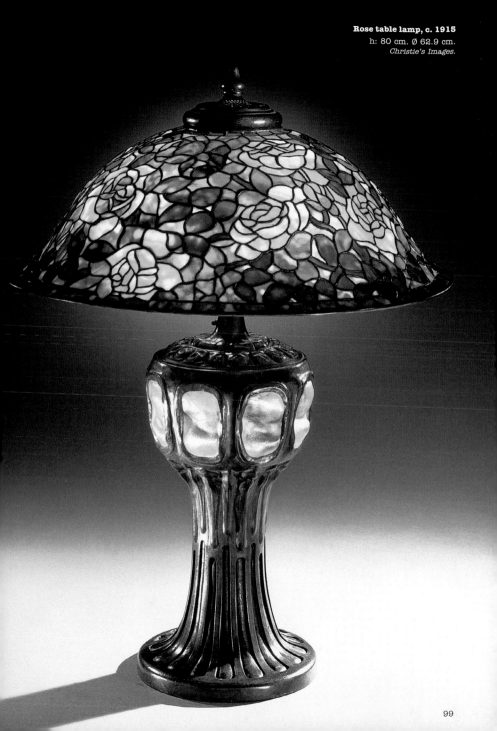

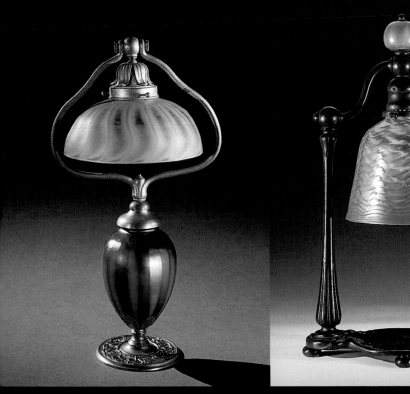

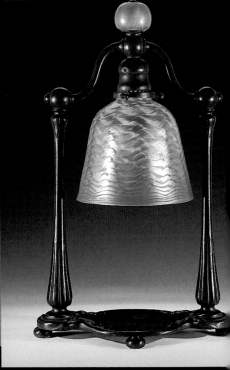

Desk lamp, c. 1904
h: 61 cm. Ø 25.4 cm.
Courtesy Phillips Auctioneers, NY.

Bell table lamp, c. 1903
h: 47 cm. Ø 16.5 cm.
Courtesy Art Focus, Zurich.

Desk lamp, c. 1900
h: 57.5 cm. Ø 25.4 cm.
Courtesy Phillips Auctioneers, NY.

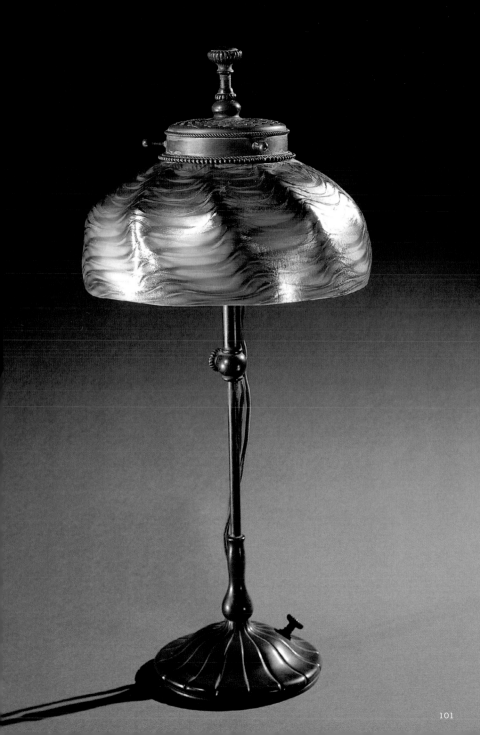

Group of Favrile glass and bronze objects

A pair of gilt bronze and Favrile glass candlesticks (h: 33 cm);
zodiac harp-arm table lamp (h: 33.6 cm);
glass desklamp (h: 43.2 cm);
Favrile glass and gilt bronze vase (h: 34.4 cm).
Courtesy Phillips Auctioneers, NY.

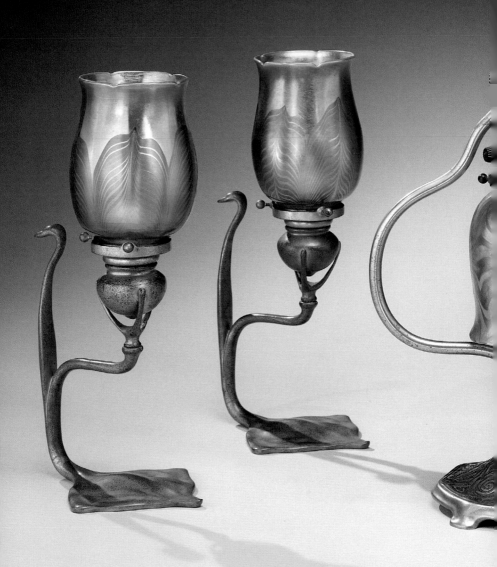

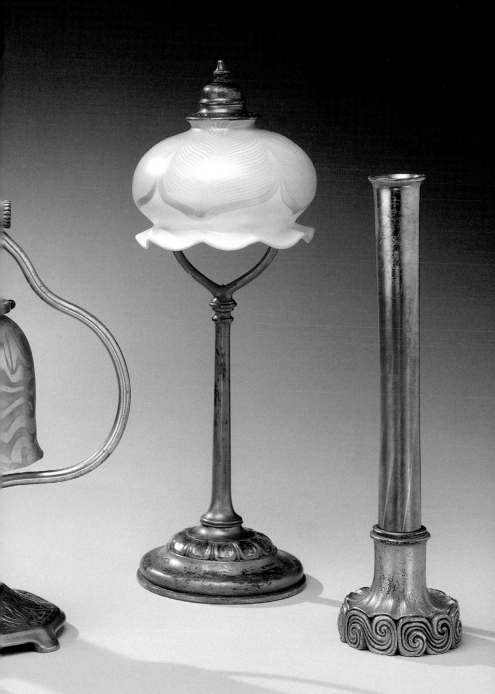

Peony table lamp (detail), c. 1902

Peony table lamp, c. 1902
h: 55.9 cm.
Courtesy Macklowe Gallery, NY.

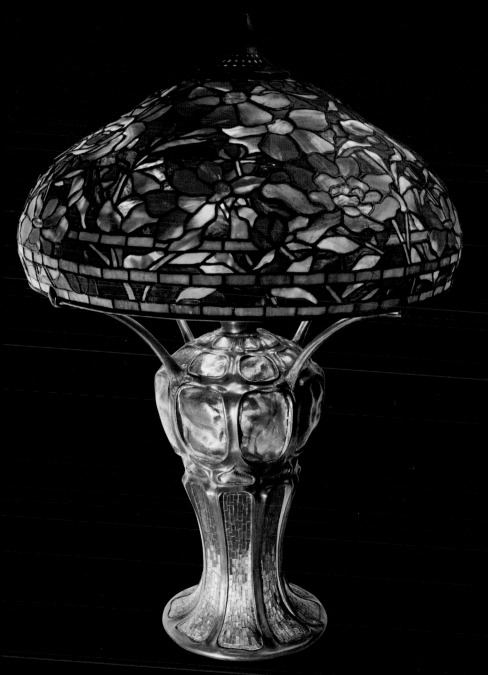

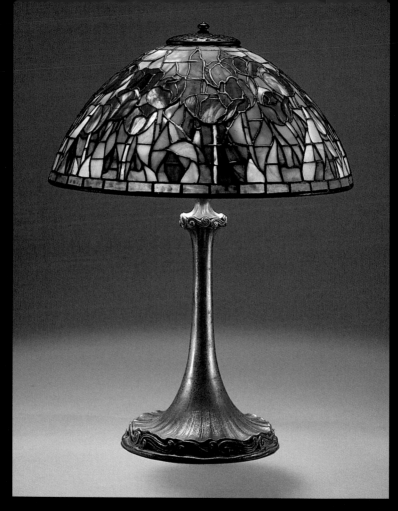

Tulip table lamp, c. 1905–1908

h: 58.4 cm.
Courtesy Doyle, NY.

**Daffodil with dogwood
bordertable lamp, c. 1905–1908**

h: 68.6 cm.
Courtesy Doyle, NY.

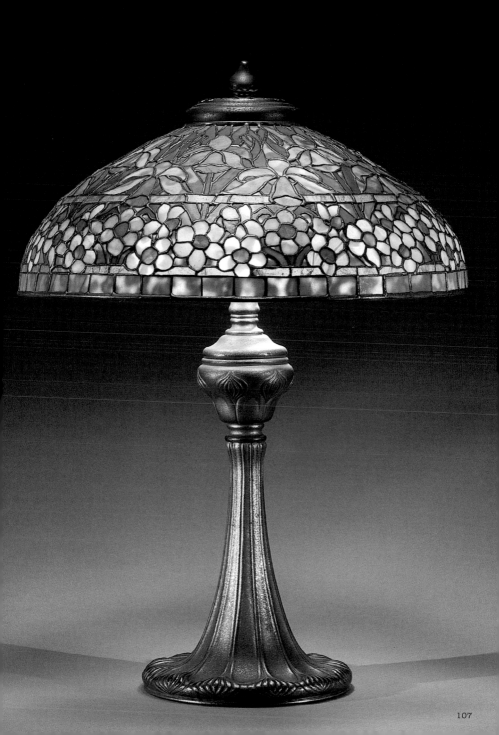

Daffodil table lamp, c. 1910–1915
h: 53.3 cm.
Courtesy Phillips Auctioneers, NY.

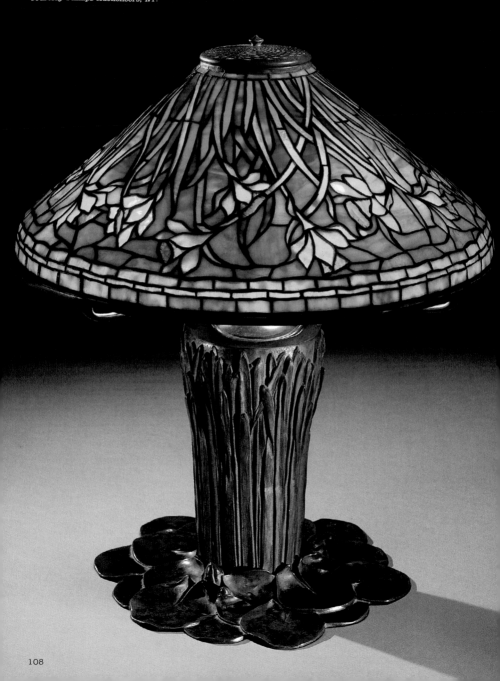

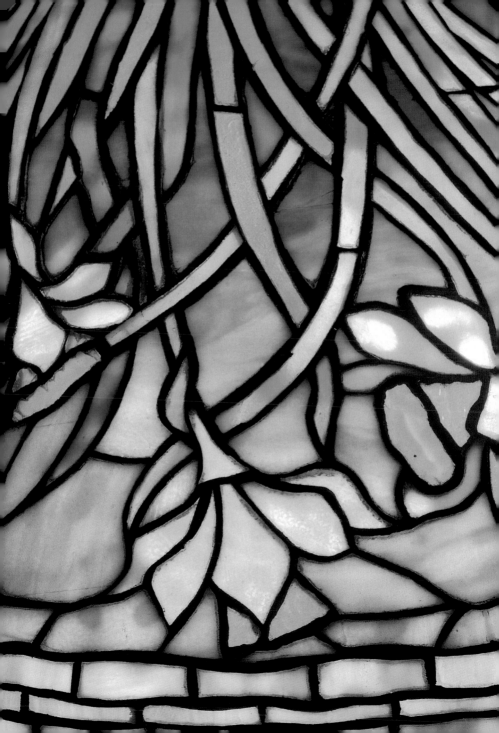

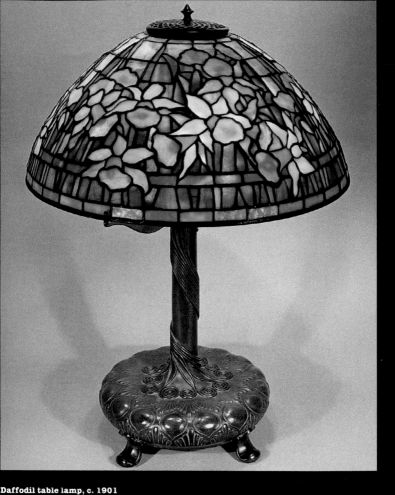

Daffodil table lamp, c. 1901

h: 40.6 cm.
Courtesy Macklowe Gallery, NY.

Daffodil and narcissus table lamp, c. 1905

h: 73.7 cm. Ø 50.8 cm.
Courtesy Art Focus, Zurich.

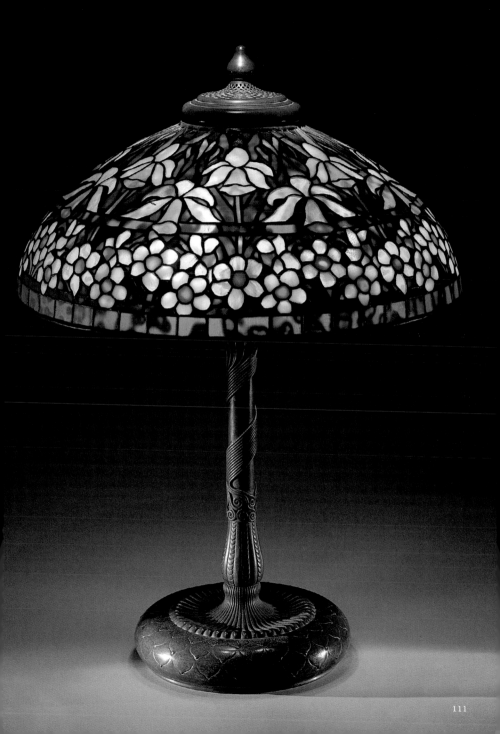

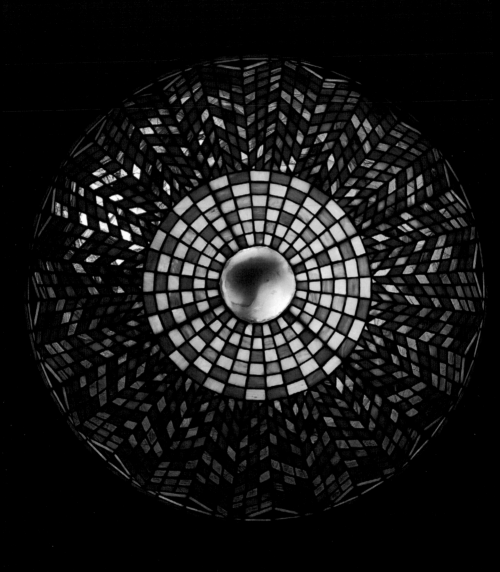

Aztec geometric lampshade, c. 1910
Ø 63.5 cm.
Courtesy Ophir Gallery, Englewood, NJ.

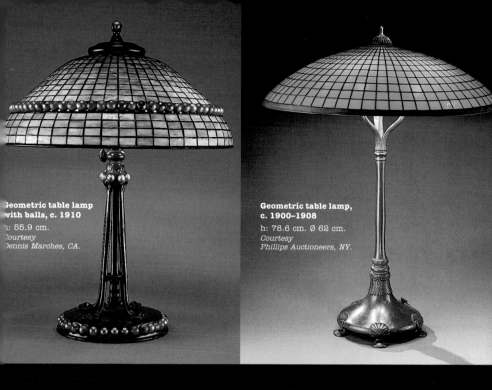

Geometric table lamp with balls, c. 1910
h: 55.9 cm.
Courtesy
Dennis Marches, CA.

Geometric table lamp, c. 1900–1908
h: 78.6 cm. Ø 62 cm.
Courtesy
Phillips Auctioneers, NY.

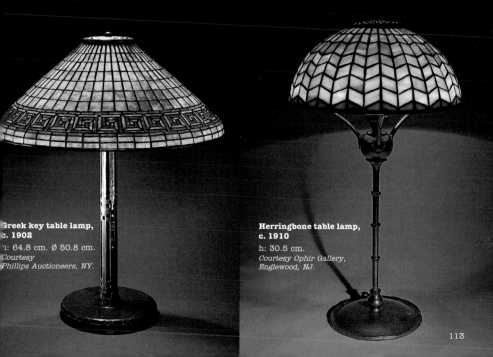

Greek key table lamp, c. 1902
h: 64.8 cm. Ø 50.8 cm.
Courtesy
Phillips Auctioneers, NY.

Herringbone table lamp, c. 1910
h: 30.5 cm.
Courtesy Ophir Gallery,
Englewood, NJ.

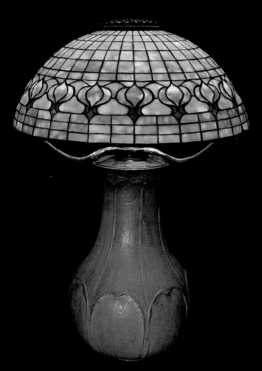

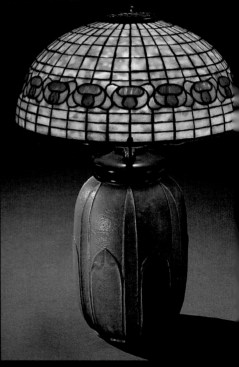

Pomegranate table lamp, c. 1910
h: 40.6 cm.
Courtesy Ophir Gallery, Englewood, NJ.

Mushroom table lamp, c. 1898
h: 56 cm. Ø 40.5 cm.
Courtesy Phillips Auctioneers, NY.

Acorn table lamp, c. 1910
h: 59 cm. Ø 45.7 cm.
Courtesy Phillips Auctioneers, NY.

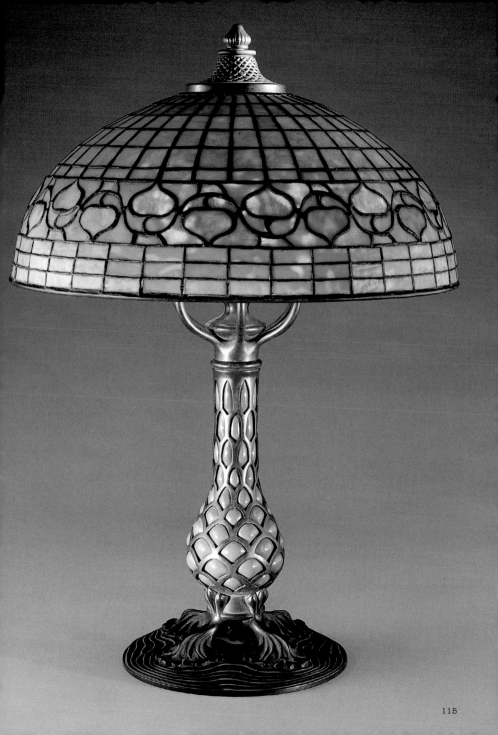

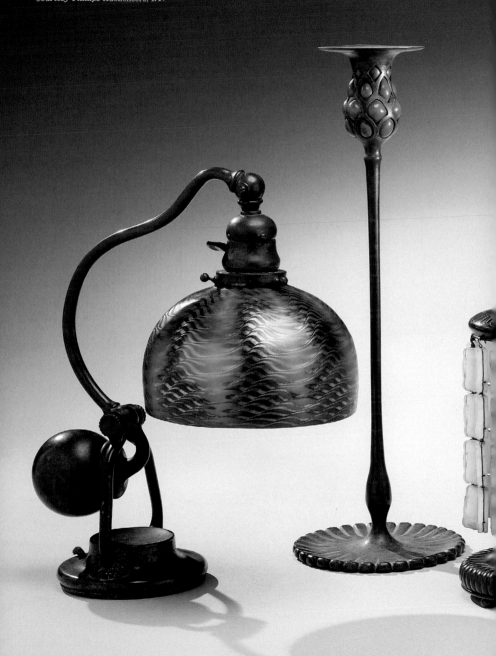

**Group of Favrile glass
and bronze lamps and candlesticks**
Courtesy Phillips Auctioneers, NY.

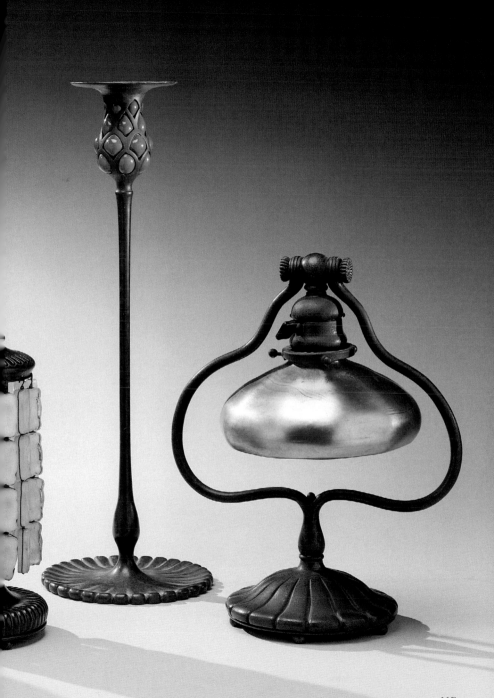

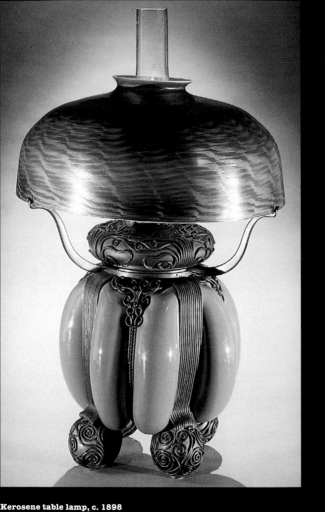

Kerosene table lamp, c. 1898

h: 68.5 cm.

Courtesy Phillips Auctioneers, NY.

Pebble table lamp, c. 1904–1910

h: 41.9 cm. Ø 36.8 cm.

Christie's Images.

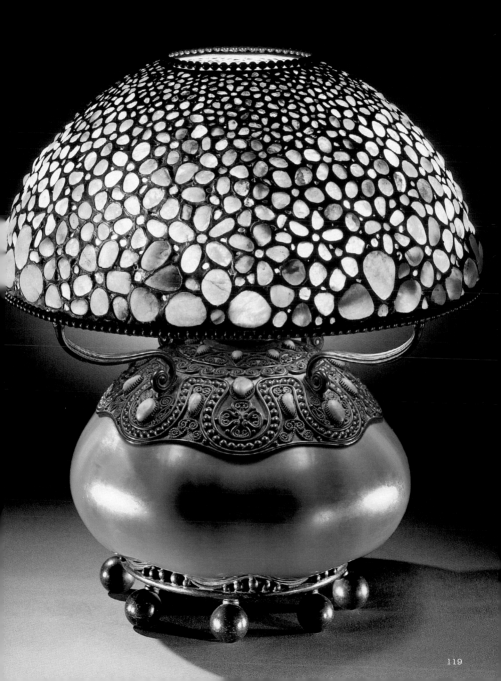

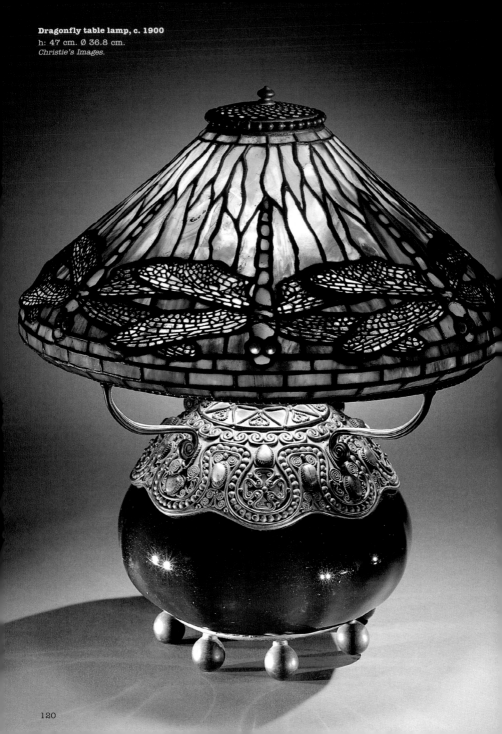

Dragonfly table lamp, c. 1900
h: 47 cm. Ø 36.8 cm.
Christie's Images.

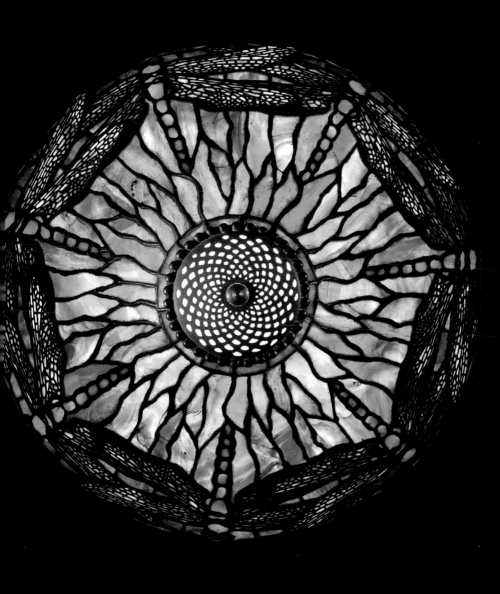

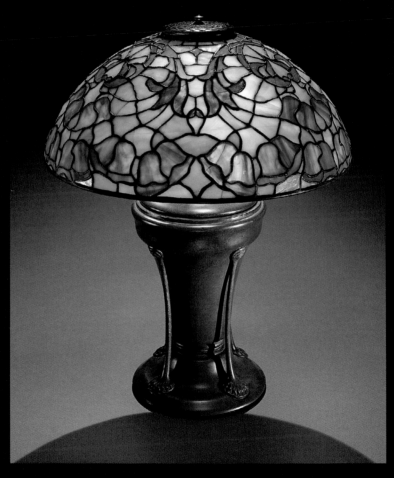

Bell flower table lamp, c. 1915
h: 55 cm. Ø 40 cm.
Courtesy Phillips Auctioneers, NY.

<div align="right">

Woodbine foliage table lamp, c. 1915
h: 66 cm. Ø 51.4 cm.
Courtesy Art Focus, Zurich.

</div>

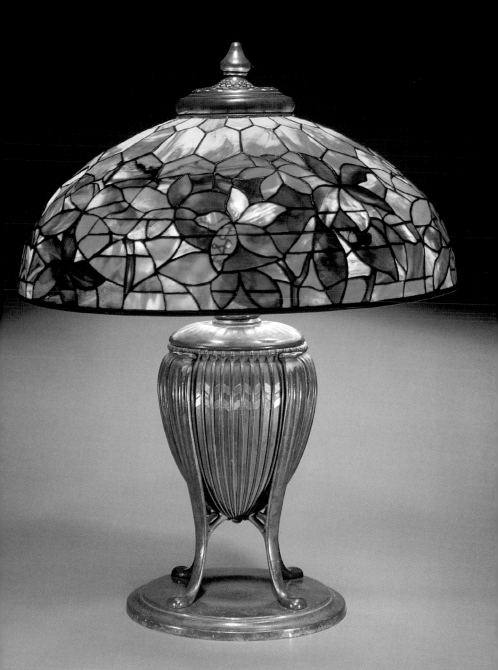

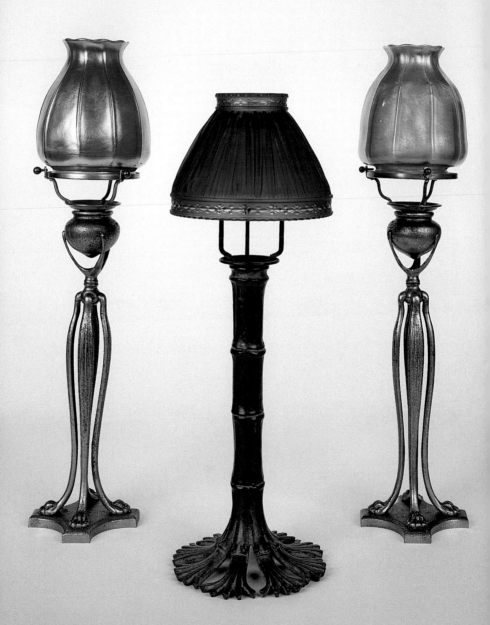

124

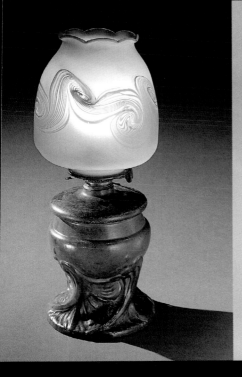

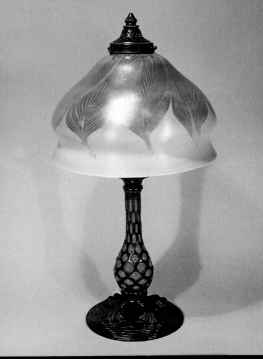

Glass and ceramic table lamp, c. 1898

h: 53.4 cm. Ø 20.3 cm.

Courtesy Phillips Auctioneers, NY.

Damascene table lamp, c. 1900

h: 35.6 cm.

Courtesy Macklowe Gallery, NY.

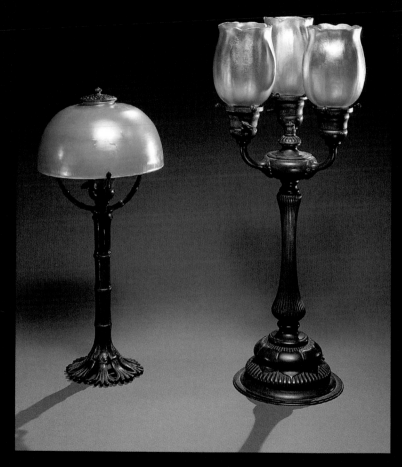

Two desk lamps, c. 1905
h: 45.7 cm. 57.5 cm.
Courtesy Phillips Auctioneers, NY.

Candlestick lamp, c. 1902
h: 44.3 cm.
Courtesy Art Focus, Zurich.

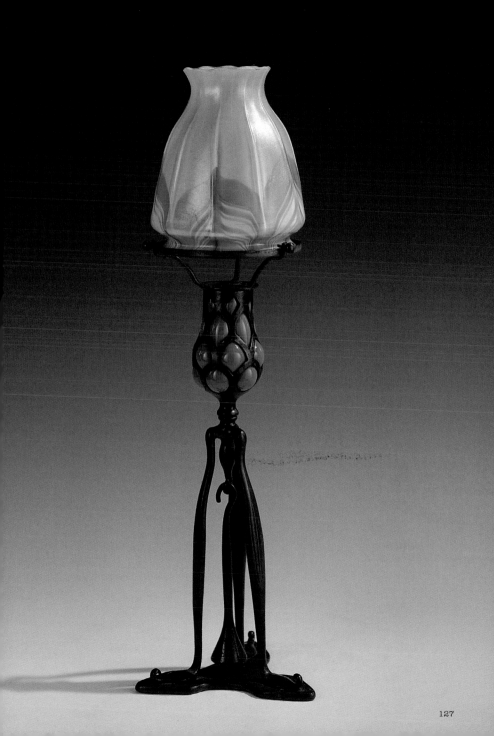

October light hanging lamp (detail), c. 1910–1915

Ø 63.5 cm.
Courtesy Ophir Gallery, Englewood, NJ.

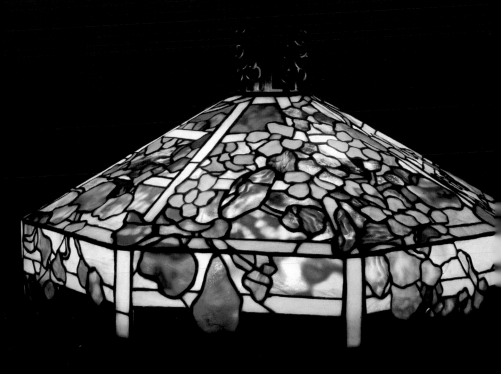

Nasturtium on trellis hanging lamp, 1903
Ø 63.5 cm.
Courtesy Macklowe Gallery, NY.

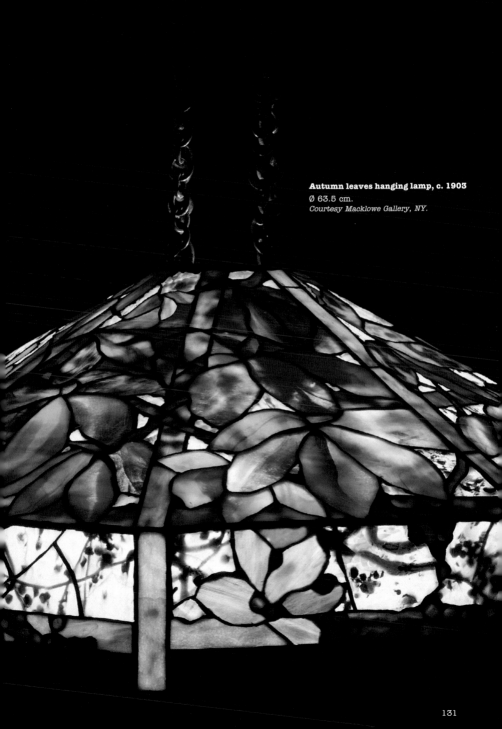

Autumn leaves hanging lamp, c. 1903
Ø 63.5 cm.
Courtesy Macklowe Gallery, NY.

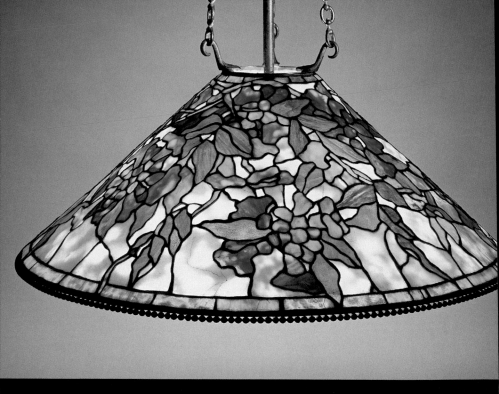

Trumpet creeper hanging lamp, c. 1903
Ø 71.1 cm.
Courtesy Macklowe Gallery, NY.

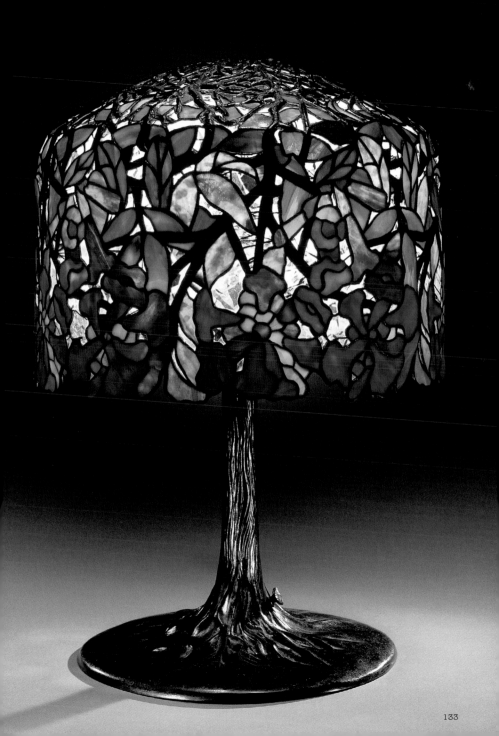

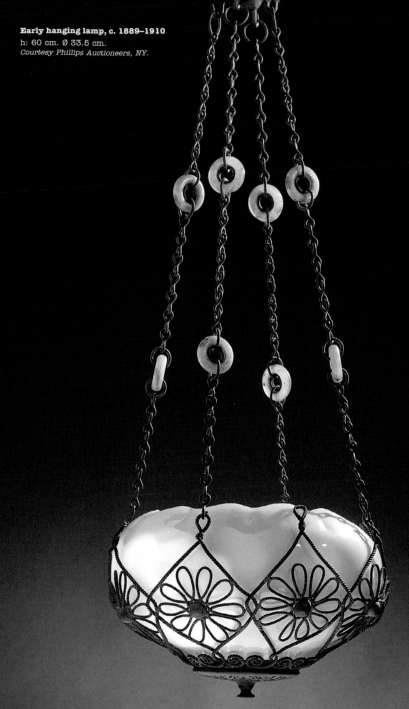

Early hanging lamp, c. 1889–1910
h: 60 cm. Ø 33.5 cm.
Courtesy Phillips Auctioneers, NY.

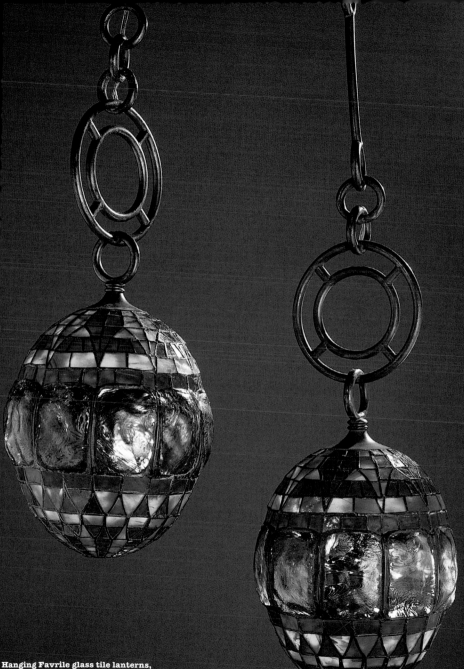

**Hanging Favrile glass tile lanterns,
c. 1898–1920**

l: 34.3 cm.
Courtesy Macklowe Gallery, NY.

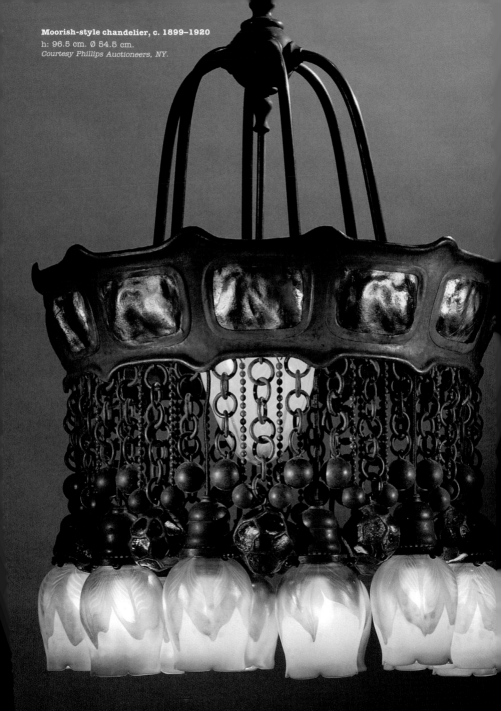

Moorish-style chandelier, c. 1899–1920
h: 96.5 cm. Ø 54.5 cm.
Courtesy Phillips Auctioneers, NY.

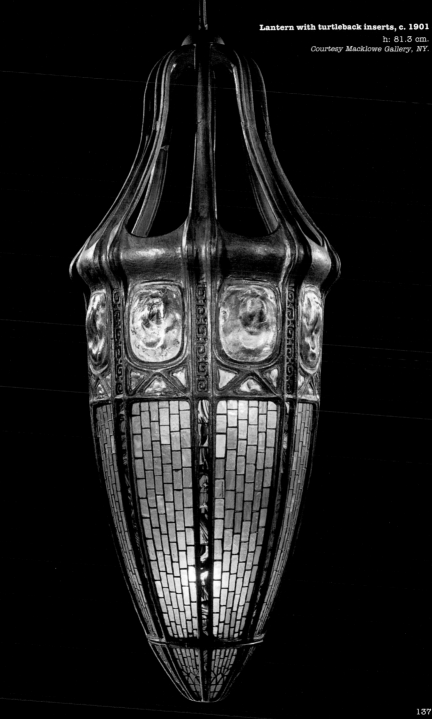

Lantern with turtleback inserts, c. 1901
h: 81.3 cm.
Courtesy Macklowe Gallery, NY.

137

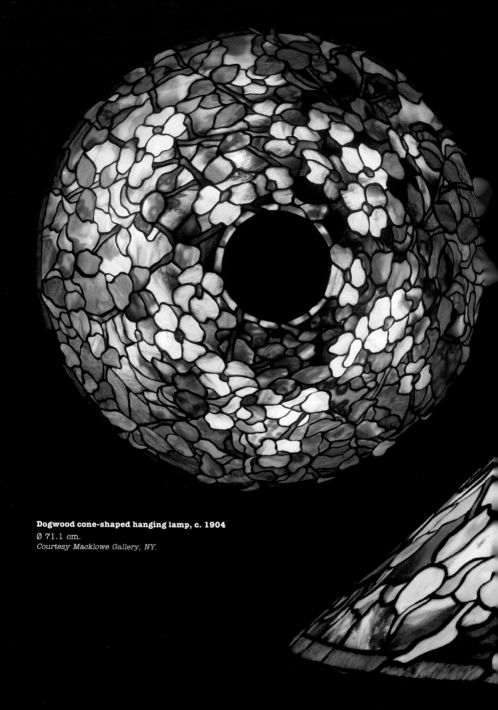

Dogwood cone-shaped hanging lamp, c. 1904
Ø 71.1 cm.
Courtesy Macklowe Gallery, NY.

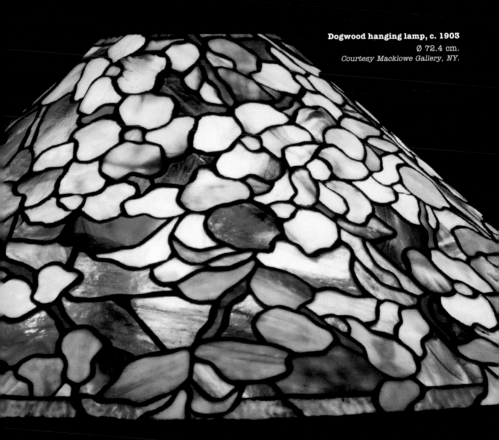

Dogwood hanging lamp, c. 1903
Ø 72.4 cm.
Courtesy Macklowe Gallery, NY.

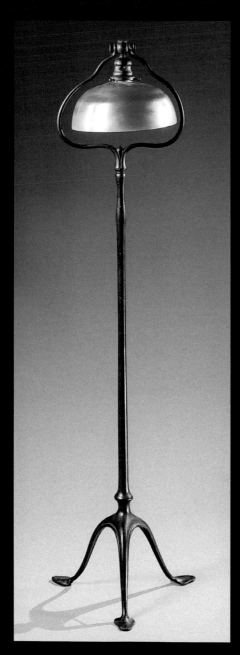

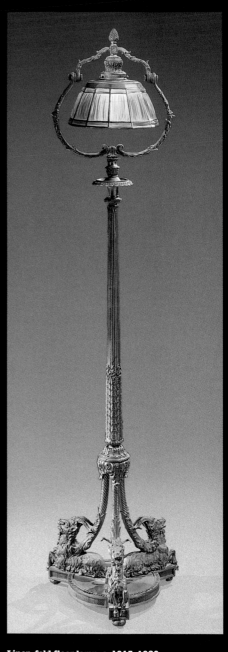

Harp-arm tripod floor lamp, 1910–1915
h: 140 cm. Ø 25.5 cm.
Courtesy Phillips Auctioneers, NY.

Linen-fold floor lamp, c. 1915–1920
h: 151 cm. Ø 24 cm.
Courtesy Phillips Auctioneers, NY.

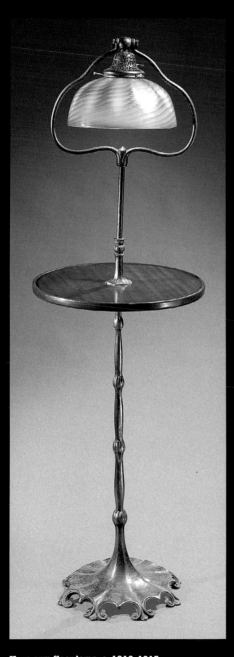

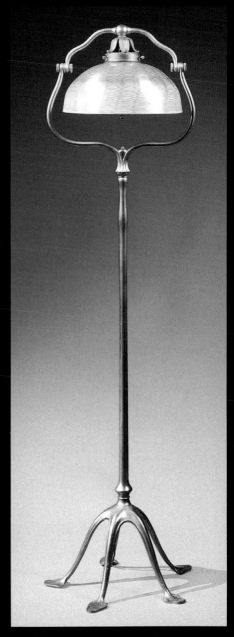

Harp-arm floor lamp, c. 1910–1915
h: 139.8 cm. Ø 26 cm.
Courtesy Phillips Auctioneers, NY.

Harp-arm damascene floor lamp, c. 1910–1915
h: 140 cm.
Courtesy Phillips Auctioneers, NY.

h: 195.6 cm. Ø 71.1 cm.
Christie's Images.

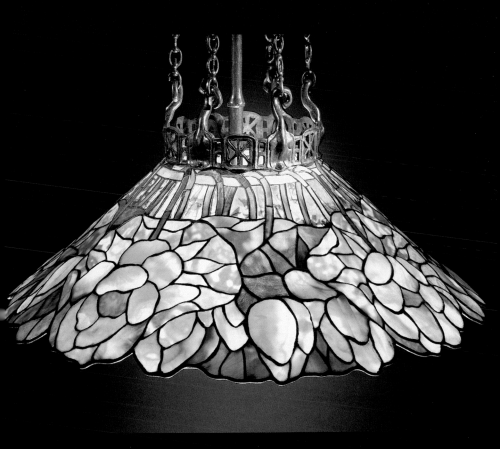

Lotus chandelier, undated
Ø 74.9 cm.
Christie's Images

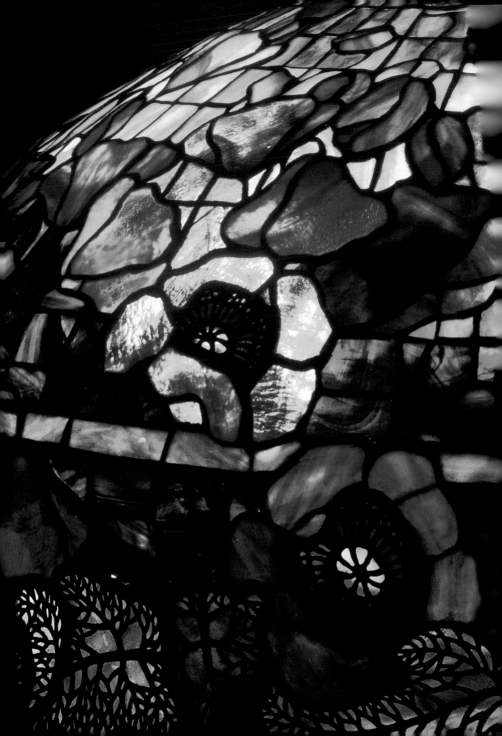

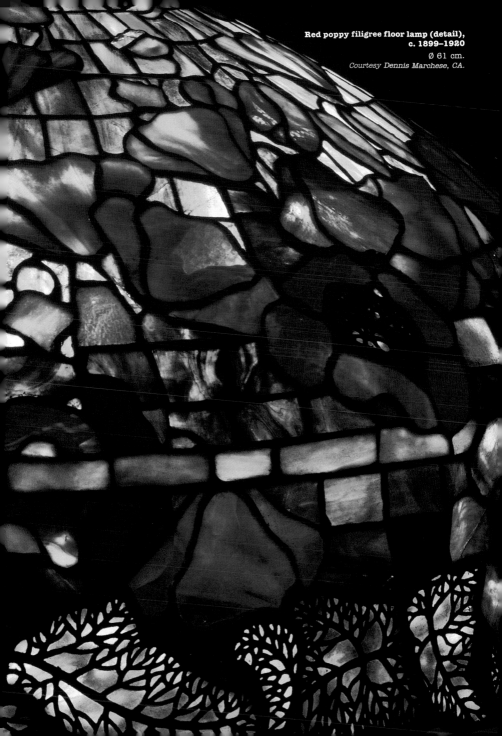

Vases
Vasen

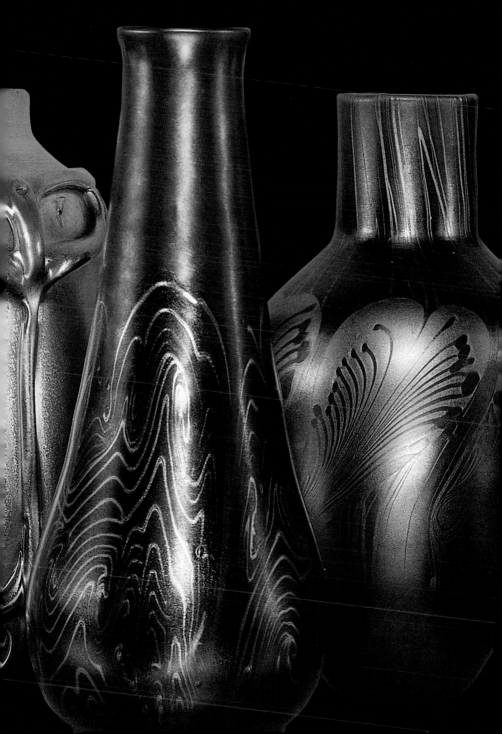

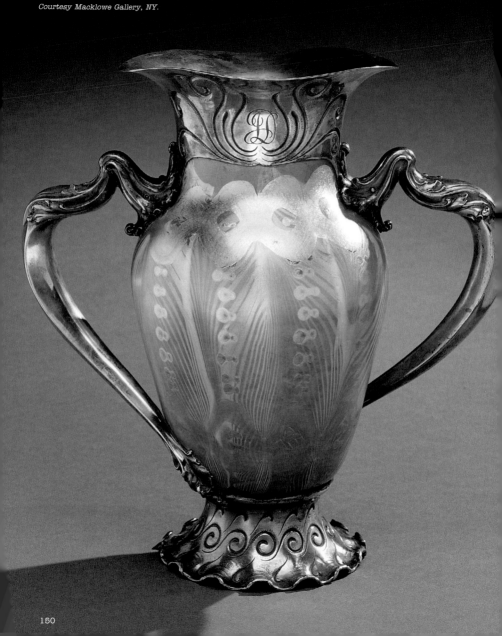

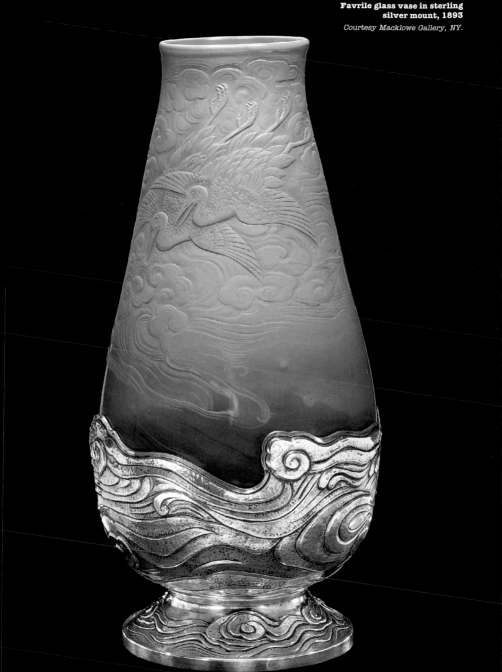

Favrile glass vase in sterling silver mount, 1893
Courtesy Macklowe Gallery, NY.

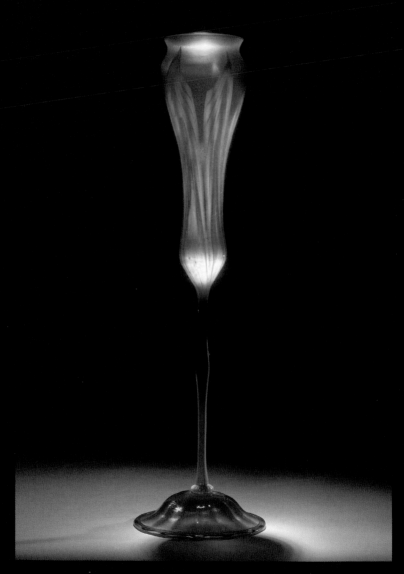

Favrile glass flower-form vase, c. 1903
h: 58.4 cm.
Courtesy Macklowe Gallery, NY.

**Favrile glass flower-form vase, c.
1900**
h: 40.6 cm.
Courtesy Macklowe Gallery, NY.

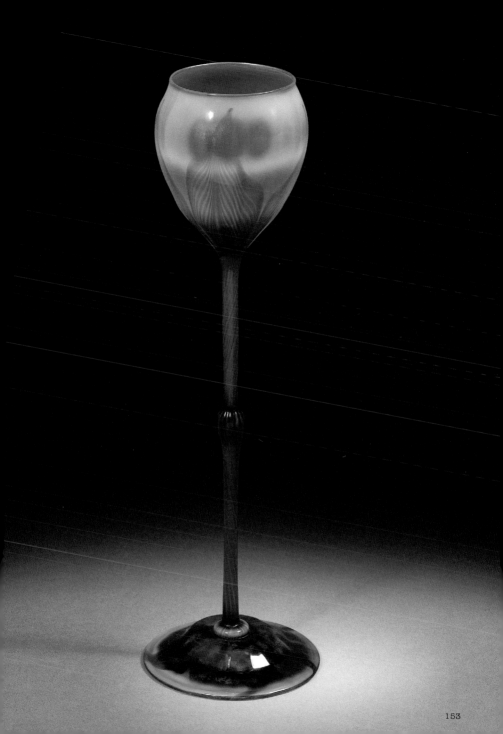

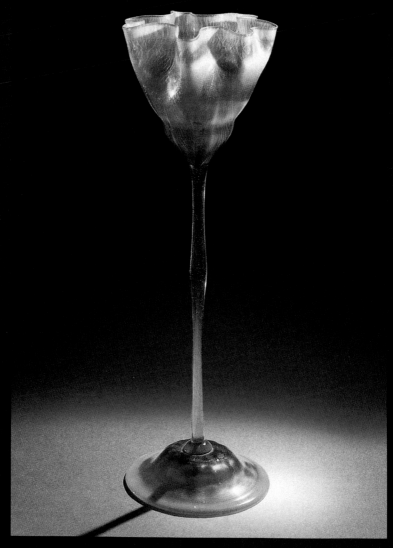

Favrile glass flower-form vase, c. 1900
h: 44.5 cm.
Courtesy Phillips Auctioneers, NY.

Favrile glass onion-form vase, c. 1903
h: 55.9 cm.
Courtesy Macklowe Gallery, NY.

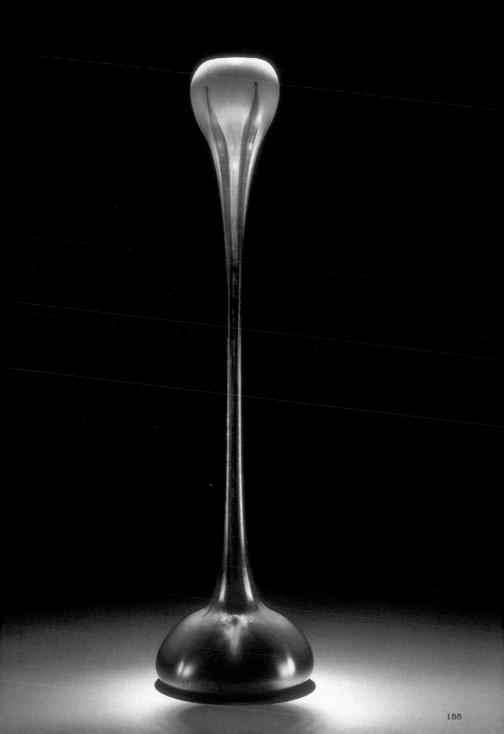

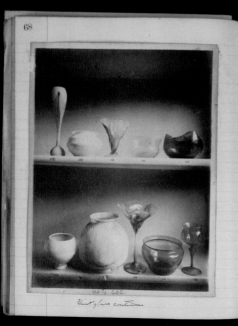

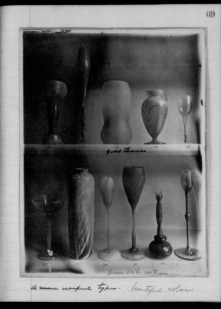

**Pages in a photograph album of Louis Comfort Tiffany
depicting objects from c. 1895 to c. 1912; with handwritten notes.**
Private collection.

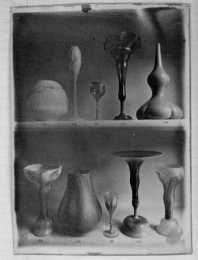

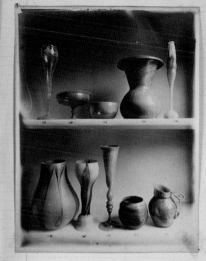

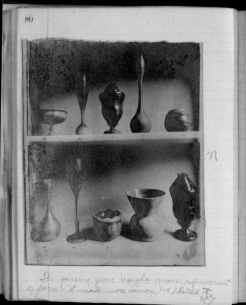

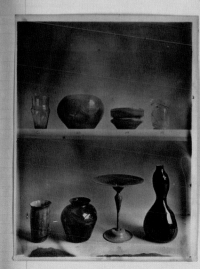

The passing years brought more refinement of form - it made more money, but I hated it.

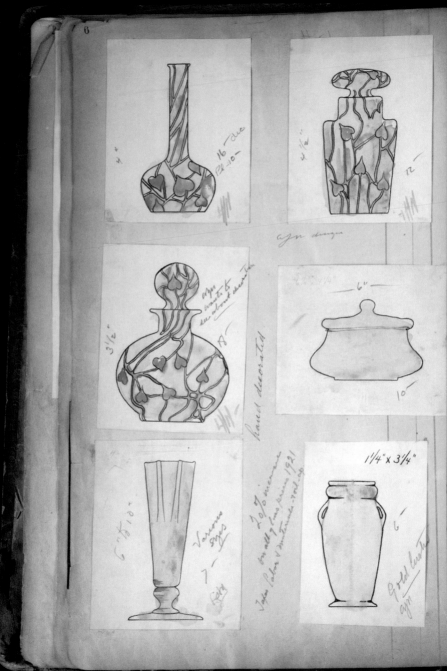

8

16 dec
12 10—

4"

H 1

2½"

12

7/111

ayn design

3½"

ayn
wants to
see about decoration

8"

Raised decorated

6"

10"

6" 5 10—

Various
sizes

7—
Red

20% increase
on all glass prices 1921
Japan Palace & Met. Enamels — red 90

1¼" x 3¾"

6"

Gold lustre
ayn

Courtesy Macklowe Gallery, NY.

Opposite page:
Watercolor sketches from a
scrap book of Tiffany, c. 1925

Christie's Images.

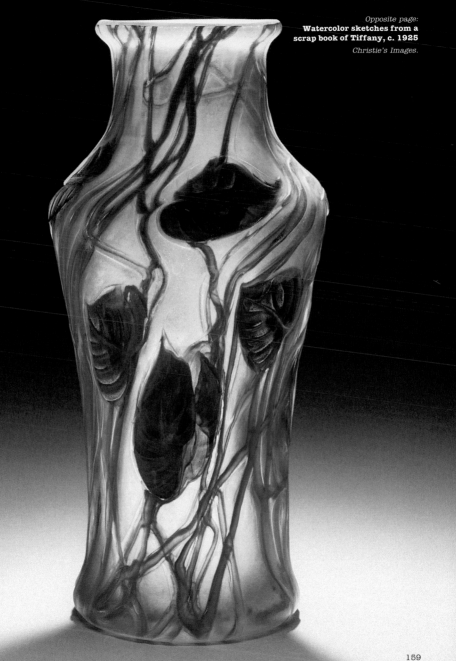

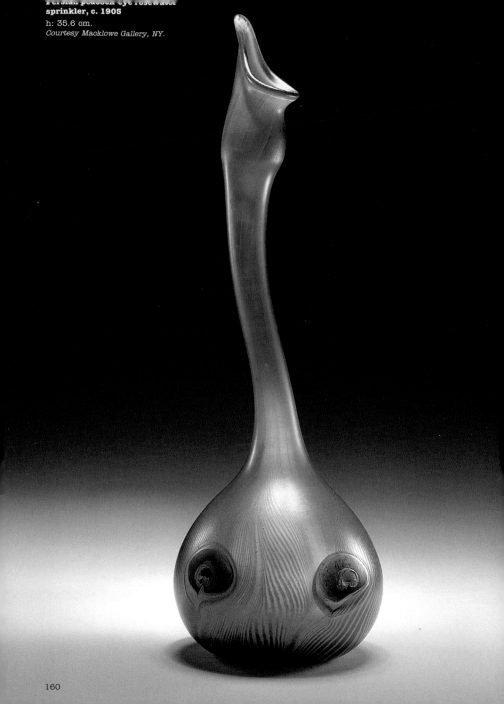

Persian peacock eye rosewater
sprinkler, c. 1905
h: 35.6 cm.
Courtesy Macklowe Gallery, NY.

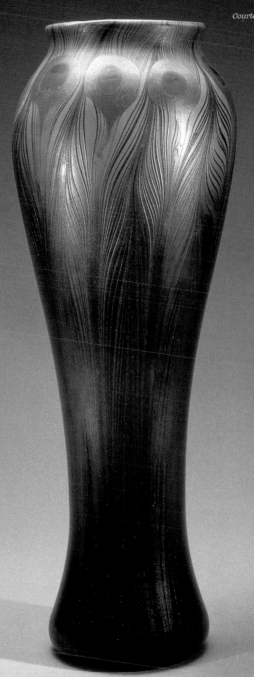

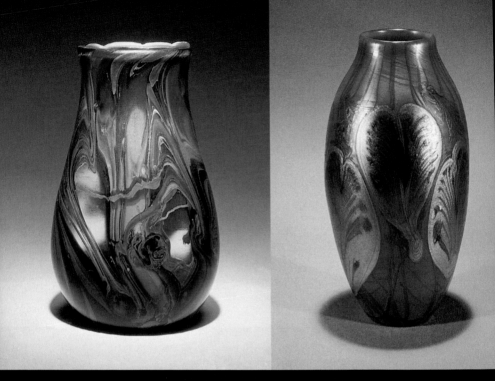

Paperweight vase with gold inserts, c. 1903

h: 45.7 cm.

Courtesy Macklowe Gallery, NY.

Leaf-and-vine vase, c. 1905

h: 30.5 cm.

Courtesy Macklowe Gallery, NY.

**Three flower-form Favrile glass vases,
c. 1896–1900**

h: 43.2 cm (left), 33 cm (center), 48.3 cm (right).

Courtesy Ophir Gallery, Englewood, NJ.

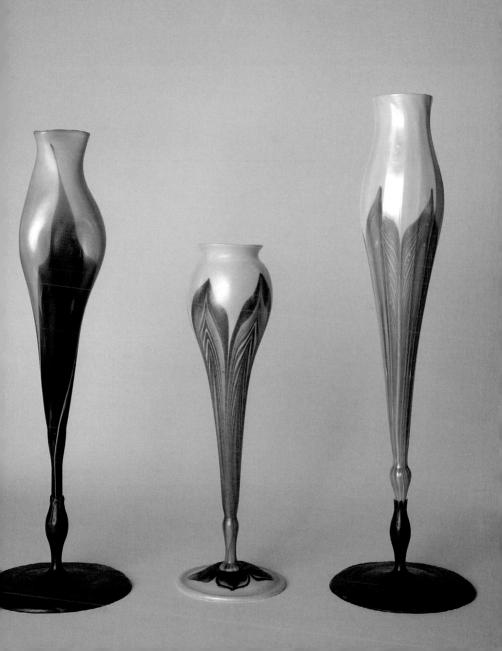

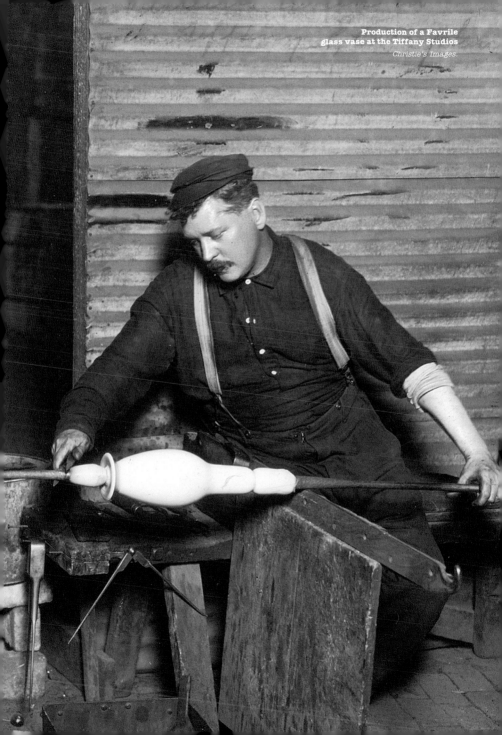

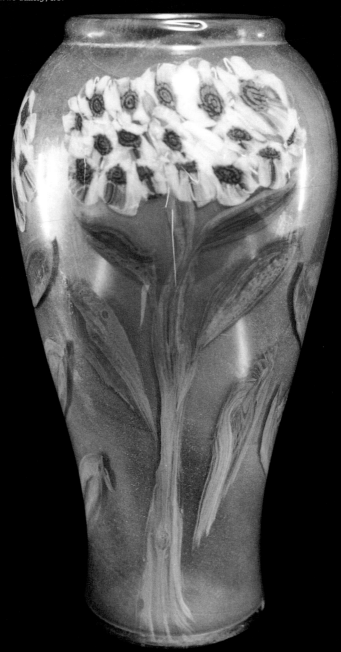

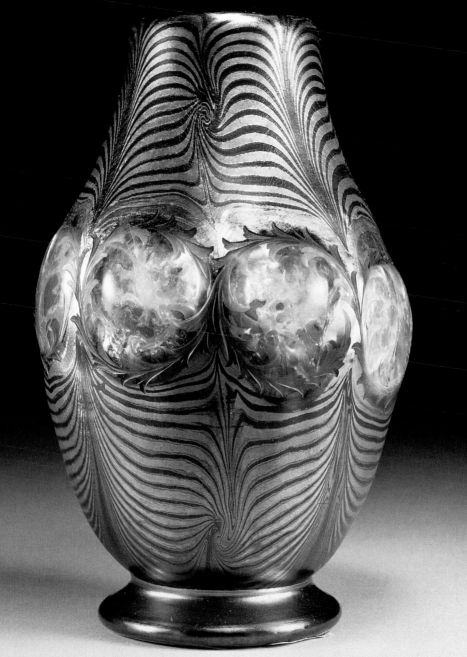

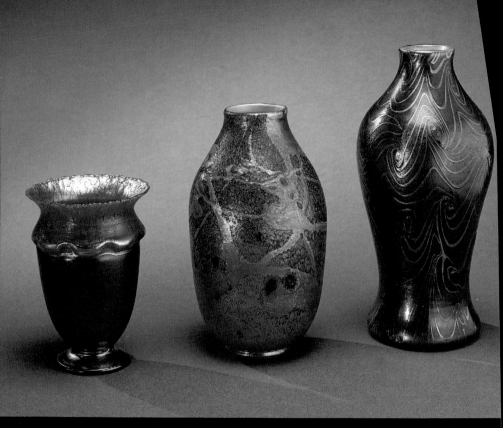

Three Favrile glass vases, c. 1905–1908
h: 14 cm / 19.1 cm / 23.75 cm.
Courtesy Phillips Auctioneers, NY.

Cypriot vase, c. 1910
h: 26 cm.
Courtesy Phillips Auctioneers, NY.

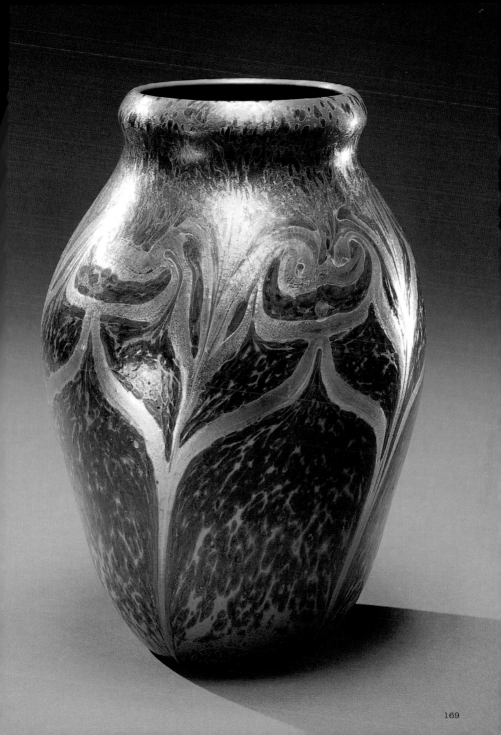

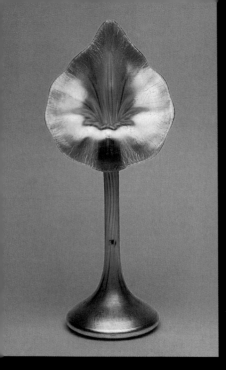

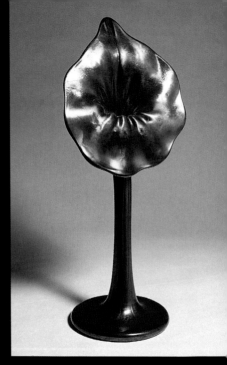

Gold Favrile glass
Jack-in-the-pulpit vase, c. 1900
h: 34.3 cm.
Courtesy Spencer Gallery, Palm Beach, FL

Blue Favrile glass
Jack-in-the-pulpit vase, c. 1900
h: 34.3 cm.
Courtesy Macklowe Gallery, NY

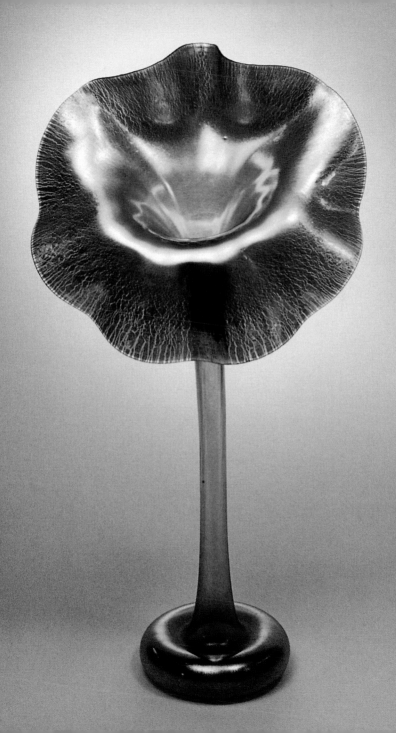

Three Favrile glass vases, c. 1903–1905
h: 50,8 cm / 8,9 cm / 38,1 cm.
Courtesy Macklowe Gallery, NY

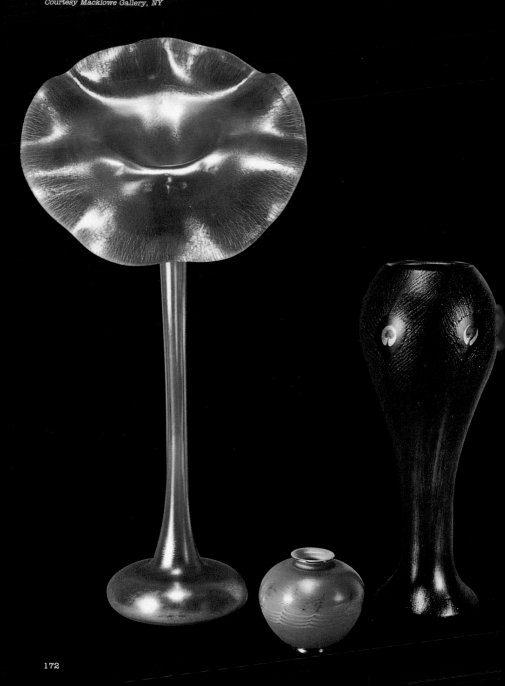

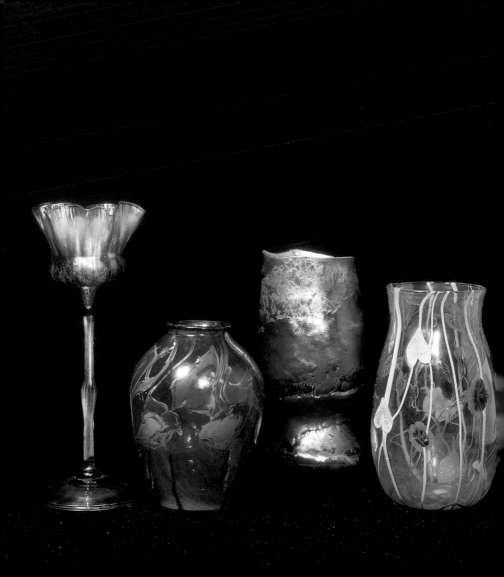

Group of vases, c. 1898–1905
Courtesy Macklowe Gallery, NY.

Midnight blue vase, c. 1898
h: 26.7 cm.
Courtesy Macklowe Gallery, NY.

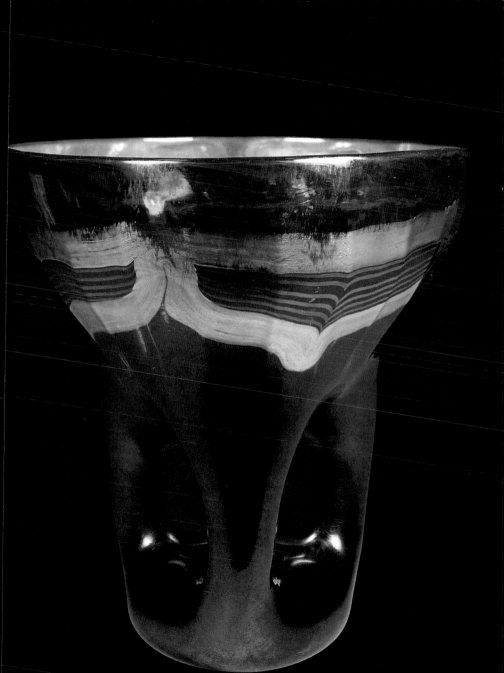

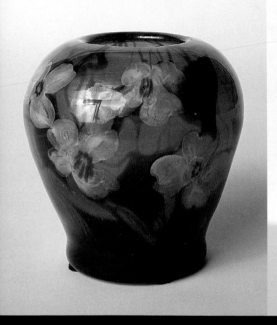

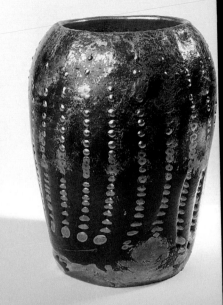

Paperweight Favrile glass vase, c. 1904
h: 22.9 cm.
Courtesy Ophir Gallery, Englewood, NJ.

Lava Favrile glass vase, c. 1907
Courtesy Ophir Gallery, Englewood, NJ.

Cameo Favrile glass vase, c. 1905
h: 20.3 cm.
Courtesy Ophir Gallery, Englewood, NJ.

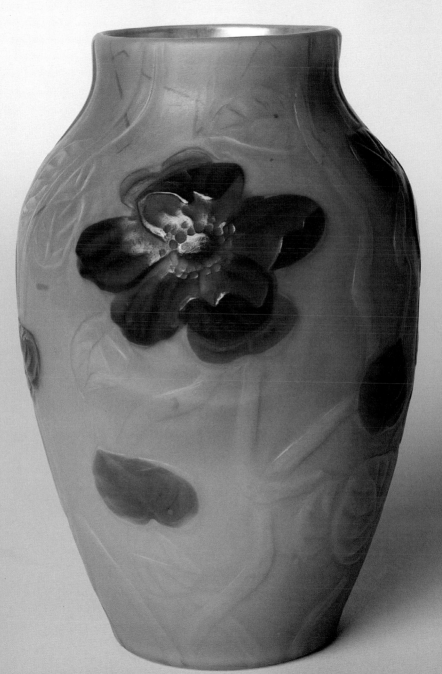

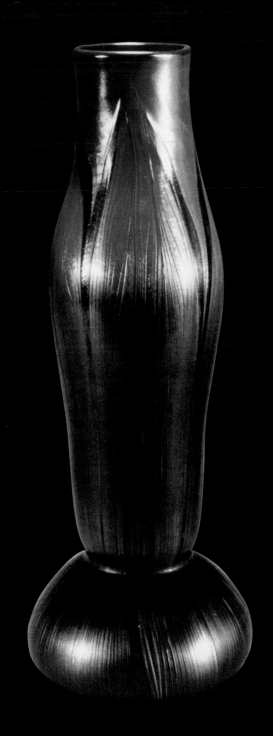

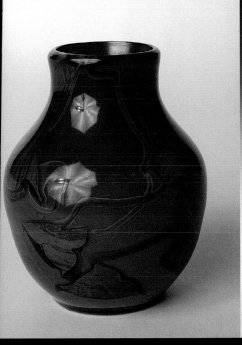

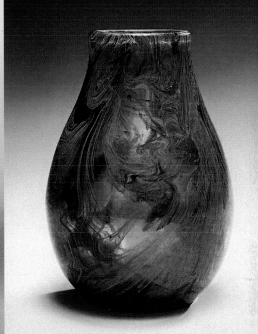

Paperweight glass vase, c. 1906
Courtesy Ophir Gallery, Englewood, NJ.

Paperweight glass vase, c. 1904
Courtesy Ophir Gallery, Englewood, NJ.

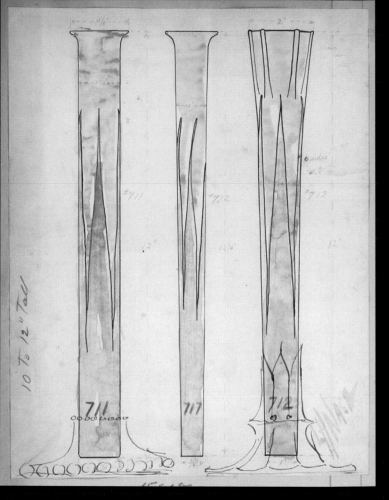

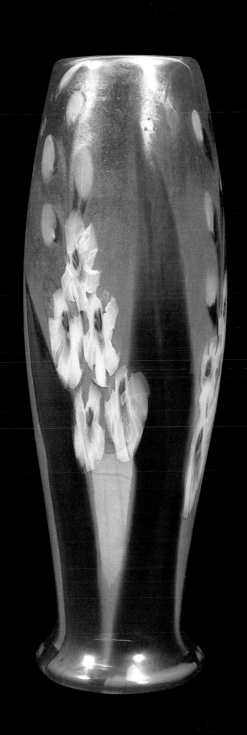

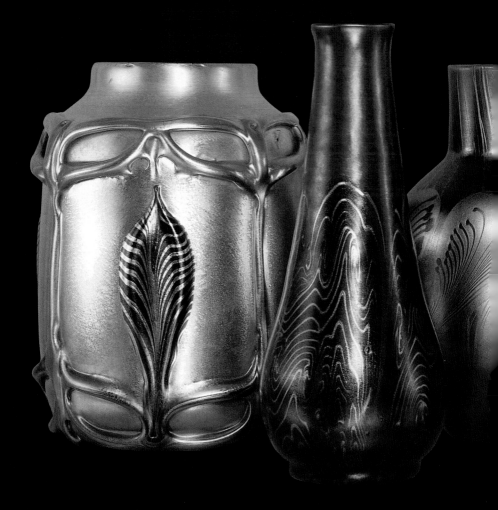

Six Favrile glass vases, c. 1898–1908
Courtesy Macklowe Gallery, NY.

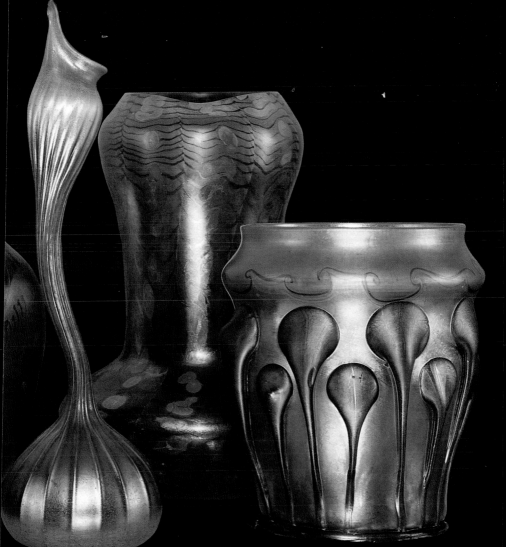

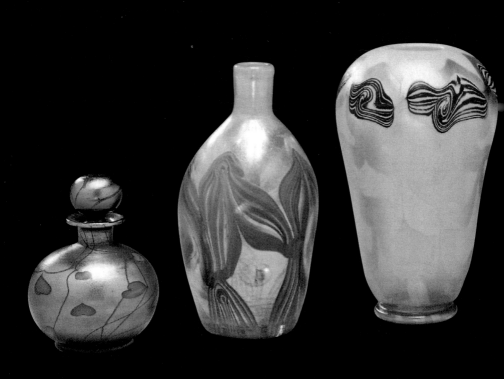

Three Favrile glass vases, c. 1900–1910
h: 53.3 cm / 32.5 cm / 17.8 cm.
Courtesy Phillips Auctioneers, NY.

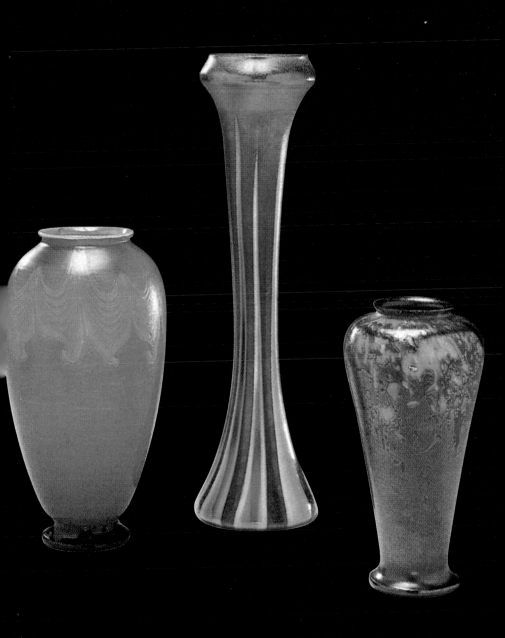

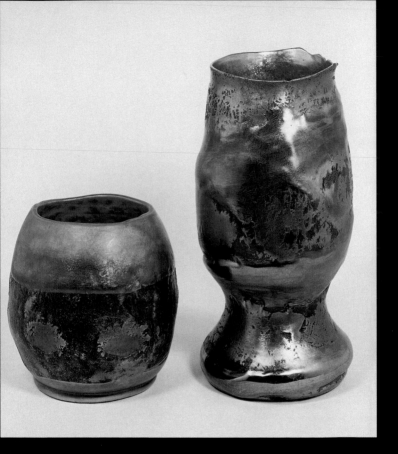

Two lava vases, c. 1910

h: 27.9 cm / 15.2 cm.
Courtesy Macklowe Gallery, NY.

Favrile glass vase with leaf motif, c. 1905

h: 59.7 cm.
Courtesy Macklowe Gallery, NY

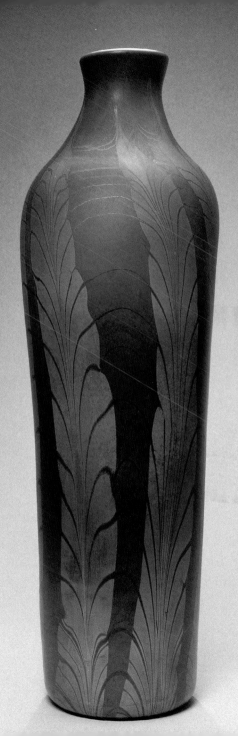

Early Tiffany Favrile Glass
1893-4 to about 1918

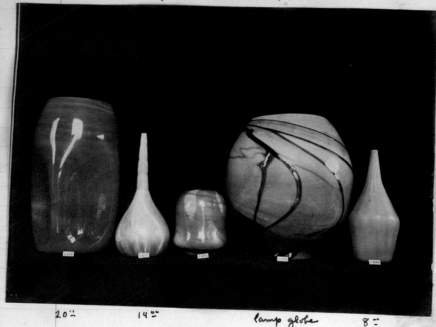

20″ 14″ lamp globe 8″

All prices of Favrile Glass — were established
not on production records but on
artistic merit — alone.

The numbers on the small tags
do not tell the age of the piece — they are
applied only when shipment is made.

numbering started from #1 to 10000
then A1 — A2 up to A10000 then B1 — B2 est
to A10000 and so on — then 1A — 2A est to 10000

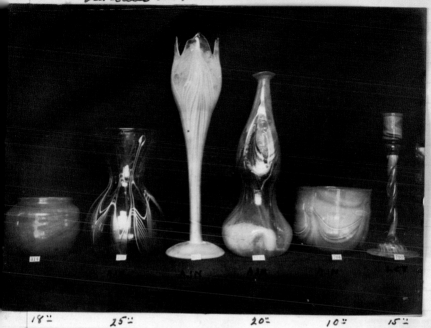

18" 25" 20" 10" 15"

All glass was marked

L C T L.C. Tiffany L.C. Tiffany Favrile

Favrile - Ex Louis C. Tiffany or Exhibition
sometimes the place - as Paris Ex Louis C Tiffany Favrile
all of the above bore a number -
 with the exception of table glass ware,
such as wine glasses and small articles
large fruit bowls will have a number
also comports - will bore a letter which
represents a certain decoration -
Small lighting glass - globe cut (Favrile)

L H Nash
Designer & Production mgr.

Bibliography / Bibliographie

Amaya, Mario. *Tiffany Glass*. New York: Walker and Sons, 1966.

Bing, Samuel; Koch, Robert. *Artistic America. Tiffany Glass, and Art Nouveau*. Cambridge, MA: The Massachusetts Institute of Technology, 1970.

Constantino, Maria. *Art Nouveau*. London: Pre-Publishing, 1999.

Couldrey, Vivienne. *The Art of Louis Comfort Tiffany*. The Weilfleet Press, 1989.

DeKay, Charles. *The Art Work of Louis C. Tiffany*. Garden City, NJ: Doubleday, Page & Co., 1914.

DeKay, Charles. *The Art Work of Louis C. Tiffany*. 2nd ed., New York, NY: Apollo, 1987.

Doros, Paul E. *The Tiffany Collection of the Chrysler Museum at Norfolk*. Norfolk, VA: Chrysler Museum, 1978.

Duncan, Alastair. *Fin de Siècle*. New York: Abbeville Press, 1989.

Duncan, Alastair. *Louis Comfort Tiffany*. New York: Harry N. Abrams, Inc., 1992.

Duncan, Alastair. *Tiffany at Auction*. New York: Rizzoli, 1981.

Duncan, Alastair. *Tiffany Windows*. New York: Simon and Schuster, 1980.

Duncan, Alastair; Eidelberg, Martin and Harris, Neal. *Masterworks of Louis Comfort Tiffany*. New York: Harry N. Abrams, Inc., 1989.

Duncan, Alastair and Yoshimizu, Tsuneo. *Masterworks of Louis Comfort Tiffany*. Tokyo: Tokyo Metropolitan Teien Art Museum, 1991.

Duncan, Alastair et al. *The World of Louis Comfort Tiffany: A Selection from the Anchorman Collection*. Japan: Greco Corporation Fine Art Department, 1994.

Feldstein, William J. Jr. and Duncan, Alastair. *The Lamps of Tiffany Studios*. New York: Harry N. Abrams, 1982.

Freilinghuysen, Alice Cooney. *Louis Comfort Tiffany at the Metropolitan Museum*. New York: Metropolitan Museum of Art, 1998.

Greenhalgh, Paul, ed. *Art Nouveau 1890–1914*. London: Victoria and Albert Museum in association with the National Gallery of Art, Washington, D.C., 2000.

Isham, Samuel. *The History of American Painting*. New York: MacMillan, 1905.

Joppein, Rüdiger et al. *Louis C. Tiffany. Meisterwerke des amerikanischen Jugendstils*. Hamburg: Museum für Kunst und Gewerbe Hamburg, 1999.

Koch, Robert. *Louis Comfort Tiffany 1848–1933*. New York: Museum of Contemporary Crafts of the American Craftmen's Council, 1958.

Koch, Robert. *Louis C. Tiffany – Rebel in Glass*. 3rd ed. New York: Crown Publishers, 1982.

Koch, Robert. S. Bing, *Artistic America, Tiffany Glass and Art Nouveau*. Cambridge, MA: Publishing Company, 1970.

Koch, Robert. *Tiffany's Glass, Bronzes, Lamps*. New York: Crown Publishers, 1971.

The Lamps of Tiffany: Highlights of Egon and Hildegard Neustadt Collection. Exhibition catalogue. Miami: University of Miami Press, 1993.

Lewis, Arnold; Turner, James and McQuillen, Steven. *The Opulent Interiors of the Gilded Age: All 203 Photographs from the "Artistic House."* New York: Dover Publications Inc., 1897.

Louis C. Tiffany. Galerie Art Focus, Collection Max Kohler. Zürich, 1997.

Louis C. Tiffany. Meisterwerke des amerikanischen Jugendstils. Cologne: DuMont, 1999.

McKean, Hugh. *The "Lost" Treasures of Louis Comfort Tiffany*. New York: Doubleday & Co., 1980.

McKean, Hugh. *Louis Comfort Tiffany* (in German). Weingarten, Germany: Weingarten, 1988.

McKean, Hugh. "The Lovely Riddle": Reflections on Art. Winterpark, FL: Charles

Hosmer Morse Foundation, Inc., 1997.

McKean, Hugh. *Tiffany's Chapel – A Treasure Rediscovered*. Winterpark, FL: Charles Hosmer Morse Foundation, Inc., 1993.

McKean, Hugh. *Treasures of Tiffany*. Exhibition catalogue. Chicago: Museum of Science and Industry, 1982.

Neustadt, Egon. *The Lamps of Tiffany*. New York: The Fairchild Press, 1970.

Objects of Art of Three Continents and Antique Oriental Rugs: The Extensive Collection Louis Comfort Tiffany Foundation. New York: Parke-Bernet Galleries, Inc., 1946.

Paton, James. *Lamps. A Collector's Guide*. New York: Charles Scribner's Sons, 1978.

Porter, Norman and Jackson, Douglas. *Tiffany*. London: Octopus, 1988.

Porter, Norman and Jackson, Douglas. *Tiffany Glassware*. New York: Crown Publishers, 1988.

Price, Joan Elliott. *Louis Comfort Tiffany. The Painting Career of a Colorist*. American University Studies, Vol. 28, 1996.

Proddow, Penny and Healy, Debra. *Tiffany et les joalliers américains*. Photographies by David Behl. Paris: Editions Vito, 1987.

Purtell, Joseph. *The Tiffany Touch*. Kingsport, TN: Kingsport Press, 1971.

Revi, Albert Christian. *American Art Nouveau Glass*. New York: Thomas Nelson & Sons, 1968.

Selz, Peter. *Art Nouveau*. Exhibition catalogue. New York: Museum of Modern Art, 1960.

Speenburgh, Gertrude. *The Arts of the Tiffanys*. Chicago: Lightner, 1956.

Spillman, Jane Shadel. *Glass from World's Fairs: 1851–1904*. Corning, NY: Corning Museum of Glass, 1998.

Steeg, Moise S. Jr. *Tiffany Favrile Art Glass*. London: Schiffer Publishing Ltd., 1997.

Stoddards, William O. *The*

Tiffanys of America: History and Genealogy. New York: Nelson Otis Tiffany Publisher, 1901.

Syford, Ethel. *Examples of Recent Works from the Studio of Louis C. Tiffany*. 1911.

Tessa, Paul. *L'art de Louis Tiffany*. Adaptation française de Philippe Plumecoq. Paris: Editions Soline, 1990.

Tessa, Paul. *The Art of Louis Comfort Tiffany*. London: Quintet, 1988.

Tiffany, Louis C. "American Art Supreme in Colored Glass." The Forum 15 (1893): pp. 621–628.

Tiffany, Louis C. "Color and its Kinship to Sound." The Art World 2 (1917): pp. 142–143.

Tiffany, Louis C. "The Gospel of Good Taste." Country Life in America 19 (November 1910): p. 105.

Tiffany, Louis C. "The Quest of Beauty." Harper's Bazaar (December 1917): pp. 43–44.

Tiffany, Louis C. "What Is the Quest of Beauty?" International Studio 58 (April 1916): p. lxiii.

Tiffany. Florence: Rizzoli, 1979.

Tiffany: Innovation in American Design. New York: Christie's, 1999.

Tiffany Studios. *Bronze Lamps*. New York: Frank Presbrey Co., 1904.

Tiffany Studios. *A Partial List of Windows*. New York: Frank Presbrey Co., 1910.

Tiffany Studios. *Tiffany Favrile Glass*. New York: Frank Presbrey Co., 1905.

Tiffany Studios. *Tiffany Favrile Glass Made under the Supervision of Mr. Louis C. Tiffany*. New York: Frank Presbrey Co., 1899.

Tiffany's Tiffany. Exhibition catalogue. Corning, NY: Corning Museum of Art, 1980.

Weisberg, Gabriel P. *Art Nouveau Bing: Paris Style 1900*. New York: Harry N. Abrams, Inc., 1986.

Wheeler, Candace. *Yesterday in a Busy Life*. New York: Harper and Brothers, 1918.

Wilie, Elizabeth and Cheek, Sheldon. *The Art of Stained and Decorative Glass*. Todtri, 1997.

Zapata, Janet. *The Jewelry and Enamels of Louis Comfort Tiffany*. London: Thames and Hudson, 1993.

Cover: **Red Lotus lamp** (detail), c. 1900–1920
Photo: Christie's Images

To stay informed about upcoming TASCHEN titles, please request our magazine at www.taschen.com or write to TASCHEN, Hohenzollernring 53, D-50672 Cologne, Germany, Fax: +49-221-254919. We will be happy to send you a free copy of our magazine which is filled with information about all of our books.

© 2004 TASCHEN GmbH
Hohenzollernring 53, D-50672 Köln
www.taschen.com

Edited by Simone Philippi, Cologne
German translation: Wolfgang Himmelberg, Düsseldorf
French translation: Simone Manceau, Paris

Cover design: Claudia Frey, Cologne
Typography: Sense/Net, Andy Disl and Birgit Reber, Cologne
Production coordination: Ute Wachendorf, Cologne

Printed in Italy
ISBN 3-8228-3470-X

Art Nouveau
Klaus-Jürgen Sembach /
Flexi-cover, 240 pp. / € 14.99 /
$ 19.99 / £ 9.99 / ¥ 2.900

Charles Rennie Mackintosh
Charlotte & Peter Fiell / Flexi-
cover, 176 pp. / € 14.99 /
$ 19.99 / £ 9.99 / ¥ 2.900

"... the most exquisite books on the planet." —*Wallpaper*,* London

"Buy them all and add some pleasure to your life."

Alchemy & Mysticism
Alexander Roob

All-American Ads 40s
Ed. Jim Heimann

All-American Ads 50s
Ed. Jim Heimann

All-American Ads 60s
Ed. Jim Heimann

Angels
Gilles Néret

Architecture Now!
Ed. Philip Jodidio

Art Now
Eds. Burkhard Riemschneider,
Uta Grosenick

Berlin Style
Ed. Angelika Taschen

Chairs
Charlotte & Peter Fiell

Design of the 20th Century
Charlotte & Peter Fiell

Design for the 21st Century
Charlotte & Peter Fiell

Devils
Gilles Néret

Digital Beauties
Ed. Julius Wiedemann

Robert Doisneau
Ed. Jean-Claude Gautrand

East German Design
Ralf Ulrich / Photos: Ernst
Hedler

Egypt Style
Ed. Angelika Taschen

M.C. Escher

Fashion
Ed. The Kyoto Costume
Institute

HR Giger
HR Giger

Grand Tour
Harry Seidler,
Ed. Peter Gössel

Graphic Design
Ed. Charlotte & Peter Fiell

Havana Style
Ed. Angelika Taschen

Homo Art
Gilles Néret

Hot Rods
Ed. Coco Shinomiya

Hula
Ed. Jim Heimann

India Bazaar
Samantha Harrison,
Bari Kumar

Industrial Design
Charlotte & Peter Fiell

Japanese Beauties
Ed. Alex Gross

Kitchen Kitsch
Ed. Jim Heimann

Krazy Kids' Food
Eds. Steve Roden,
Dan Goodsell

Las Vegas
Ed. Jim Heimann

Mexicana
Ed. Jim Heimann

Mexico Style
Ed. Angelika Taschen

Morocco Style
Ed. Angelika Taschen

**Extra/Ordinary Objects,
Vol. I**
Ed. Colors Magazine

**Extra/Ordinary Objects,
Vol. II**
Ed. Colors Magazine

Paris Style
Ed. Angelika Taschen

Penguin
Frans Lanting

20th Century Photography
Museum Ludwig Cologne

Pin-Ups
Ed. Burkhard Riemschneider

Provence Style
Ed. Angelika Taschen

Pussycats
Gilles Néret

Safari Style
Ed. Angelika Taschen

Seaside Style
Ed. Angelika Taschen

Albertus Seba. Butterflies
Irmgard Müsch

**Albertus Seba. Shells &
Corals**
Irmgard Müsch

Starck
Ed Mae Cooper, Pierre Doze,
Elisabeth Laville

Surfing
Ed. Jim Heimann

Sydney Style
Ed. Angelika Taschen

Tattoos
Ed. Henk Schiffmacher

Tiffany
Jacob Baal-Teshuva

Tiki Style
Sven Kirsten

Tuscany Style
Ed. Angelika Taschen

Women Artists
in the 20th and 21st Century
Ed. Uta Grosenick

ICONS